IMAGES
of America

CLAY COUNTY

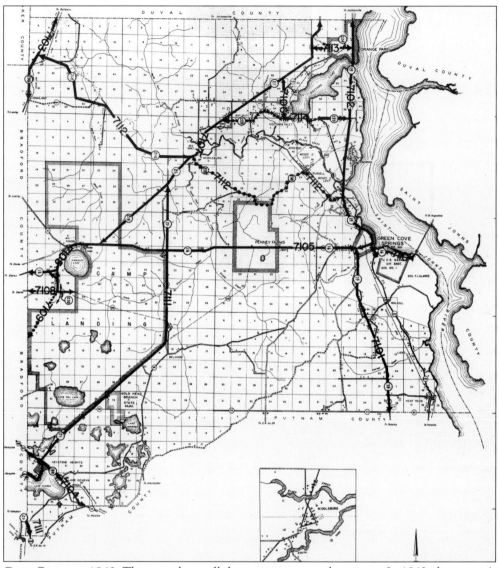

CLAY COUNTY, 1942. This map shows all the major towns in the county. In 1940, the county's population was 6,468.

IMAGES
of America

CLAY COUNTY

Kevin S. Hooper

ARCADIA

Published by Arcadia Publishing
an imprint of Tempus Publishing Inc.
Charleston SC, Chicago, Portsmouth NH, San Francisco

Printed in Great Britain

Library of Congress Catalog Card Number: 2004100863

For all general information contact Arcadia Publishing at:
Telephone 843-853-2070
Fax 843-853-0044
E-mail sales@arcadiapublishing.com
For customer service and orders:
Toll-Free 1-888-313-2665

Visit us on the internet at http://www.arcadiapublishing.com

CONTENTS

ACKNOWLEDGMENTS

Many individuals were instrumental in helping to create this work, and I am thankful that they were willing to share their knowledge and open their collections to me. Claude Bass at the Clay County Archives was generous in opening the archives to me for research after normal hours. Lisa Avery and the staff at the Matheson Museum in Gainesville, Florida, were very courteous and helpful in copying images from the museum's collection. I also wish to thank the members of the Clay County Historical Commission in their effort to push me to start this project: Jennifer Knight, Scott Knight, Sue Page, Gayward Hendry, Pat Mueller, John Bowles, Tom Nicholson, Orlando Tibbetts, Marilyn Haddock, Jeannie Brockhausen, and Thom Parham. I also wish to thank Dr. Dan Schafer, Edna McDonald, David Starling, and Jerry Casale for all the great stories about Clay County history.

This book is dedicated to my family: Kammy, Luke, Emmalee, and Levi. Thanks to each of you for your patience and cheerfulness on days that I traveled to do research among old papers and pictures. And to Mom and Dad, words are too little to convey my thanks.

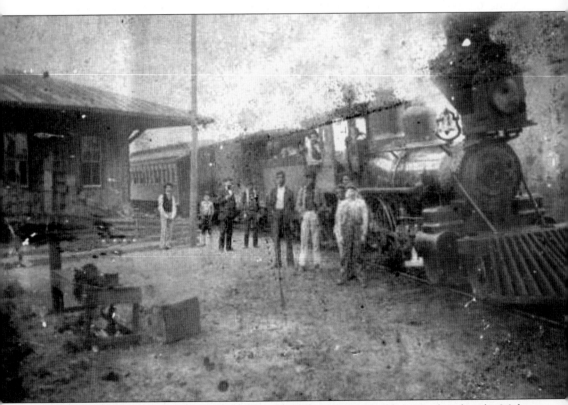

MELROSE RAILROAD STATION. Shown is Green Cove Springs Melrose Railroad at the Melrose Station. (Courtesy of Florida Photographic Archives.)

INTRODUCTION

Clay County, located in Northeast Florida, played an important role in Florida's history, even though the county was not created until 1858. As settlers migrated into the area, the lands surrounding Black Creek, which flowed east to the St. Johns River, became one of the most populated parts of what was then Duval County. After the Federal Road was constructed through the area in December 1826, the town of Whitesville was established, and it received the first post office in 1828. Thanks to the Federal Road and the ability of steam packets to navigate far up Black Creek to Garey's Ferry, the area became a gateway to the Florida frontier. When war with the Seminoles erupted in 1835, Garey's Ferry became the supply depot for the U.S. Army on the east coast of Florida, and on July 4, 1836, the post was named Ft. Heileman. Because of the vast destruction and panic caused by the Indian attacks, Garey's Ferry found itself one of the few towns on the Florida frontier not to be abandoned. After the war the residents found themselves laden with debt and a faltering economy, but by the late 1840s prosperity started to become reality.

During the years between the Second Seminole War and the creation of Clay County, residents struggled to gain their independence from Duval County. Finding themselves politically outvoted and isolated, men like George Branning, Ozias Buddington, and Elijah Blitch continued the push to break away. On November 30, 1858, John G. Smith introduced a bill to the House of Representatives in Tallahassee to formally divide the county of Duval and to organize a new county called Clay. On December 31, 1858, Clay County was officially created by the Florida Legislature. Middleburg was named the county seat until a formal county election could be held to decide where the permanent seat should be. In October 1859 the residents voted that Whitesville, located about two miles to the southwest, should be the new county seat. Just a little over a year later the state voted for secession and Clay County was once again ravaged by war.

During the Civil War, Clay County residents were fairly isolated from the destruction brought on by the war. It was not until mid-1864 that the county had its first military battle. Union troops brought from Jacksonville had established a fort at a place called Magnolia on the St. Johns River. From there they would send small detachments out to raid for cattle. On one such engagement, a few warehouses in Whitesville were burned, but men from the 2nd Florida Cavalry under the command of Capt. J.J. Dickinson waited for their return to Magnolia. The forces fought for about an hour with only a handful of Union soldiers able to make their way back to Magnolia. The Confederates did not suffer any casualties.

After the war the county found its population had shifted towards the St. Johns River, and in 1871 a county election was held to vote on a new location for the county seat. The outcome of the vote was that the new county seat was to be in Green Cove Springs. When the move occurred it was discovered that many of the county records were missing. Charges were brought against the county clerk, Barney McRae, but a trial concluded that the theft of the missing records was committed by "persons or a person unknown." These missing records included the minutes from the county commission and the land deeds for the years 1859 through 1871.

After the war, Jacksonville and other towns up river started to become winter resort areas for many returning northern citizens. People found the area exciting with its mild winter climate. With the economy recovering and Florida becoming a winter tourist destination, the area found itself being called upon to provide hotels for the steamboats that traveled the St. Johns

River. Orange Park, Hibernia, Magnolia Springs, and Green Cove Springs became destinations for travelers, and Green Cove Springs became a resort area. A few books describing the towns were published in the late 19th century, including *A Guide-Book of Florida* by Daniel G. Brinton and *A Winter in Florida* by Bill Ledyard, both published in 1869. By the mid-1870s Magnolia Springs became the "Saratoga of the South."

Following the success of the Magnolia Hotel other wealthy entrepreneurs seized on the idea of enhancing the drawing power of the spring. The Union House was rebuilt and called the St. Clair with the St. Elmo being built just north of it and the Riverside Cottage along the St. Johns River. Near the spring the Clarendon, the Oakland, and several small boarding houses were established. These hotels were able to successfully establish themselves as winter resorts for the northern traveler. When the Clarendon opened in 1871 it had a taxable value of $15,000. By 1899, the year before it was destroyed by fire, its value was assessed at $70,002.14. Because of the success of the hotels many business were established; some of the larger ones had inventory valued at $25,000–$30,000, with $50,000 in sales per year.

As the area became known as a winter resort, the town of Green Cove Springs voted for incorporation on November 2, 1874, followed by Orange Park on February 18, 1879. Throughout the rest of the century the lands along the St. Johns River continued to prosper until the freezes of 1894–1895. This freeze successfully halted the "orange mania" that had swept the area; seeing that the area was not safe, orange groves were abandoned and moved south. When Henry Flagler built his railroad to Miami, tourists started to migrate further south; as the tourism industry moved south, one by one the winter hotels either closed or became apartments.

It was not until World War II that the county regained notice, but this time it was from the military. Construction on Camp Blanding was started in 1939 and it soon became a training base for the army. Several small airfields for the navy were also constructed in the county, including Brannon Field and Thunderbolt. In the 1950s the navy built a base at Green Cove Springs to house a mothball fleet, but the base did not last long. In the early 1970s the county, like all of Northeast Florida, started to grow. Today the population of the county exceeds 140,000 and it is the 26th largest county in the state. I now invite you to sit down and travel back 130 years to a time when the steamboat provided transportation along the St. Johns River and tourists found first-rate winter hotels. It was now time for Clay County to grow.

One
MIDDLEBURG

Middleburg is the oldest town in Clay County. Though the area was referenced during the British period, 1763–1784, it was not until the second Spanish period, 1784–1821, that a few families started to settle in the area. It was not until after the United States had acquired the Florida territories in 1821 that the area started to grow. In December 1826 the government completed the section of the Federal Road that crossed Black Creek. This road ran from South Georgia to Ft. Brooke in Tampa. In 1828 the citizens of the area petitioned Congress for a post office, and the Whitesville Post Office was officially designated on May 8, 1828. When war against the Seminoles broke out in December 1835, the area, then known as Garey's Ferry, found itself one of the few towns not abandoned, and a flood of refugees filled the area. The population rose to over 1,000 inhabitants. After the war the area became desolated as most moved farther south due to the Armed Occupation Act. In the early 1850s the area became known as Middleburg and on May 1, 1851, the post office in Garey's Ferry moved to Middleburg. Lumber, turpentine, and farming became the staple occupations. When Clay County was established, Middleburg became the temporary county seat, but in the summer of 1871 the county seat changed to Green Cove Springs as those towns along the St. Johns River became more economically important. By 1885 a stage between Green Cove Springs and Middleburg was running three times a week. Middleburg quietly became isolated because the railroad bypassed the town, and it was not until the start of construction on Camp Blanding in 1939 that prosperity returned.

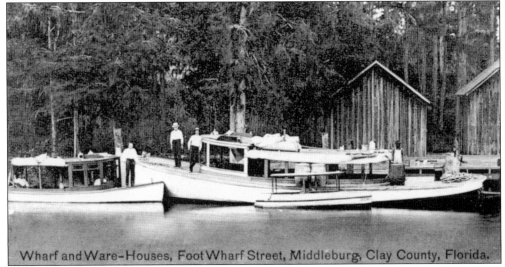

Wharf and Ware-Houses, Foot Wharf Street, Middleburg, Clay County, Florida.

WHARF AND WAREHOUSES AT THE FOOT OF WHARF STREET. Because the community decided to have the railroad bypass the town, Black Creek provided the only easy route to travel to Jacksonville. Along the creek were several saw mills.

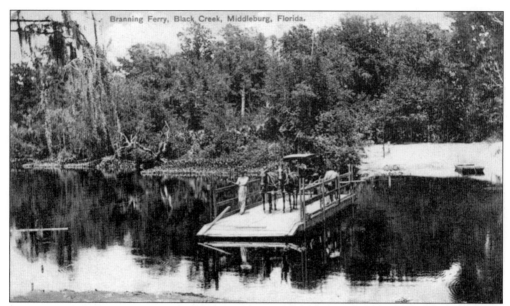

BRANNING'S FERRY. The Branning family had been providing passage across the north prong of Black Creek since the 1840s, when George Branning constructed a small bridge to compete against Samuel Y. Garey's ferry. By 1900 passage on the ferry between the hours of 6 a.m. and 7 p.m. was free, and on Sunday between the hours of 9 a.m. and 4 p.m. the ferryman was exempt from duty.

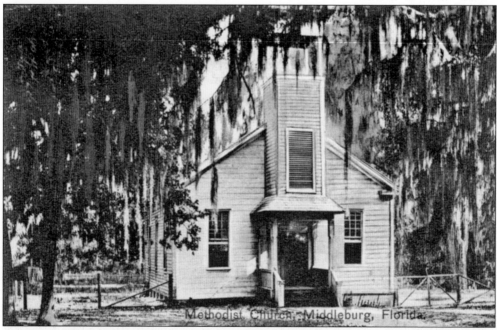

MIDDLEBURG METHODIST CHURCH. The Middleburg Methodist Church is one of the oldest buildings in town. Built sometime between 1847 and 1851, it is the oldest Methodist church continually used in the state. The cemetery behind the church was used as a public cemetery throughout the 19th and early 20th centuries. The other town cemeteries were located at Whitesville and Garey's Ferry.

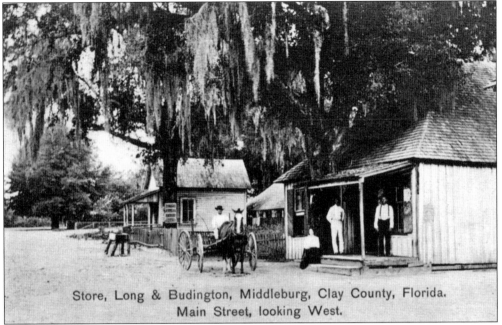

Store, Long & Budington, Middleburg, Clay County, Florida.
Main Street, looking West.

LONG AND BUDINGTON STORE ON MAIN STREET LOOKING WEST. This store was located in Middleburg at the intersection of Palmetto, Wharf, and Main Streets. George Long and Frosard Budington operated the store. The intersection pictured was the hub of Middleburg's business district.

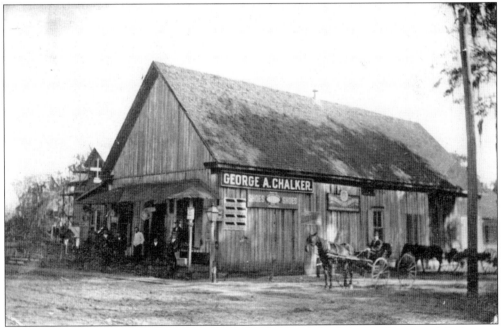

GEORGE A. CHALKER'S STORE. Chalker's store was located opposite of Long and Budington Store. George was the son of Albert S. Chalker, who moved to Middleburg in the early 1850s. The store was located at the corner of Thompson Street—now Wharf Street—and Main Street. Notice just to the left of Chalker's store the Haddon house is under construction.

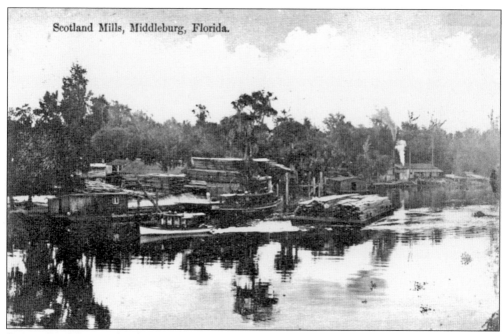

Scotland Mills, Middleburg, Florida.

SCOTLAND MILLS. This lumberyard was located on the north prong of Black Creek and was part of the Jennings Artesian Farm Land Company, which was started by Gov. William Bryan Jennings. (Courtesy of Middleburg Historical Museum.)

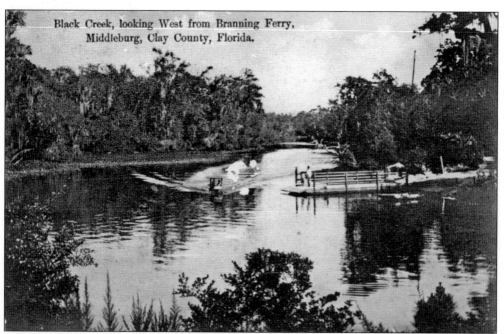

Black Creek, looking West from Branning Ferry, Middleburg, Clay County, Florida.

BLACK CREEK LOOKING WEST FROM BRANNING FERRY. Many ferries were located on Black Creek. Middleburg's isolation because of poor roads and no railroad meant that ferries tended to exist longer on Black Creek. The last ferry on Black Creek was at Rideout and it closed June 11, 1960. (Courtesy of Middleburg Historical Museum.)

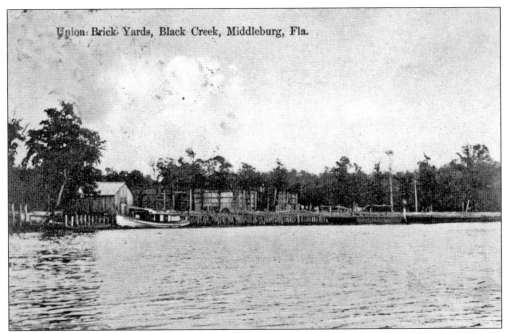

Union Brick Yards, Black Creek, Middleburg, Fla.

UNION BRICKYARD. The Union Brickyard was located just east of the forks of Black Creek and was established in the late 19th century. The yard remained open until the early 20th century, when it closed due to the poor quality of clay being mined.

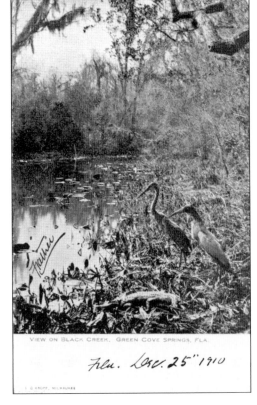

VIEW ON BLACK CREEK, GREEN COVE SPRINGS, FLA.

PICTURESQUE BLACK CREEK. Black Creek offered the Northern visitor picturesque views of Florida's natural frontier. For $12, parties from Green Cove Springs and Hibernia could travel up the creek and picnic on its banks. A favorite sport for the men was to shoot alligators that lurked on the banks of the creek.

BLACK CREEK C. 1870S BY ISAAC HAAS. This is one of the earliest known pictures of Black Creek. In 1881 it was said that the scenery along its banks was equal to that of the Ocklawaha. The creek was the lifeblood of Middleburg and it provided the quickest and best means of transportation to and from Jacksonville.

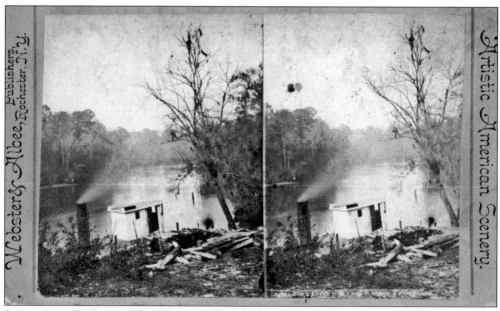

STEAMBOAT *TWILIGHT*. The steamboat *Twilight* was owned and operated by Albert S. Chalker. The boat was built in Jacksonville in 1883. Initially the ownership of the vessel was split between Chalker and William S. Wightman when Chalker purchased a half share from Wightman for $1,200.

14

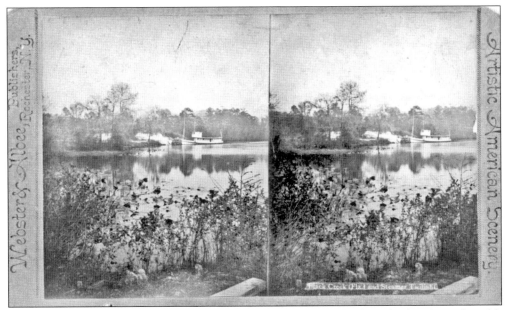

STEAMBOAT TWILIGHT. The *Twilight* was a vessel of 18 tons with a length of 61 feet, a breadth of 5 feet, and a draft of 3 feet. The Chalkers made a daily trip to Jacksonville that took 4.5 hours. The fare was $1.

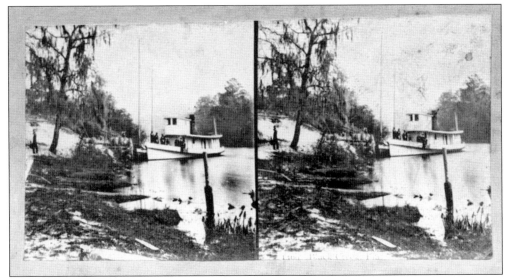

STEAMBOAT TWILIGHT. By 1890 Albert's sons George A. and William R. Chalker had purchased the other half interest of the vessel from William Wightman for $500. On July 30, 1887, the boat sunk and an engineer named Conner went missing. Two days later his body was found floating in the creek. Although murder was suspected it was later speculated that he was killed by glass when falling out the cabin as the ship rolled and sank.

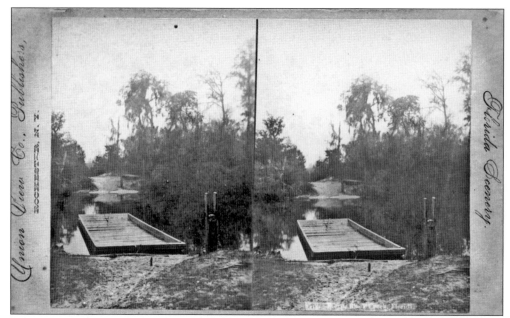

FERRY CROSSING ON BLACK CREEK. This image shows a typical ferry crossing on Black Creek. A ferryman was employed by the county at a monthly rate of $30. As the population along the creek shifted so did the ferry crossings. Many of the old crossings can still be found today and they include Moss, Frisbee, Branning, Chalker, Knight, and Hagan.

LOVER'S RETREAT, BLACK CREEK BY ISAAC HAAS. This is a strange title for a picture that shows a man who appears to be hunting duck or other animals. Far up the creek past the forks, Black Creek becomes very narrow and shallow. Today the creek still retains much of the wildlife that drew tourists to it over 130 years ago.

Two
ORANGE PARK

Orange Park was incorporated on February 18, 1879. The Florida Winter Home and Improvement Co., founded by Washington G. Benedict, created the town. In 1876 Benedict purchased some 9,000 acres, which included the old Zephaniah Kingsley plantation called Laurel Grove. The new town would be situated on a piece of property encompassing seven miles of waterfront along the St. Johns. Benedict and others laid out the town with streets as wide as 100 feet. A pier was built that extended 1,400 feet into the St. Johns River. By 1885 the town consisted of a fine winter hotel, three stores, numerous "pretty cottages, a public school, and no saloon." In its early years, the Park View Hotel was visited by several famous individuals. President Ulysses S. Grant and Gen. Phil Sheridan visited on January 8, 1880. When the great freeze of 1895 struck in January and February it essentially ended the orange grove production in the town. Orange Park was able to continue to grow at the start of the 20th century, and its population had increased to 700 by 1910. In 1920 the Loyal Order of Moose met and decided to purchase 26 acres of property for their organization. This property included the Hotel Marion, formally the Park View Hotel.

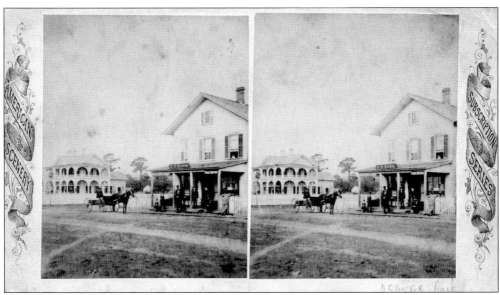

THE STORE OF EDWARD D. SABIN AND THE ORANGE PARK POST OFFICE. Sabin had two stores, one that sold groceries and one that sold dry goods. In 1882 Sabin partnered with A.L. Evans. By 1885 the inventory was valued at $8,000. The post office was established in 1877 and was located off Kingsley Avenue. (Courtesy of Matheson Museum.)

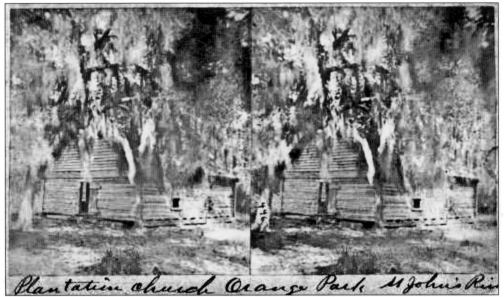

Plantation church Orange Park St Johns Riv

PLANTATION CHURCH. The church was one of the last remaining structures from the Kingsley/Mcintosh Plantation. Kingsley established Laurel Grove in 1803 after acquiring 2,600 acres on the St. Johns River. In 1812, during the Patriot Rebellion, Kingsley had to fortify his house against invaders from Georgia who were trying to end Spanish control of Florida. By 1814 Kingsley had sold his plantation and moved to Ft. George Island. (Courtesy of Florida Photographic Archives.)

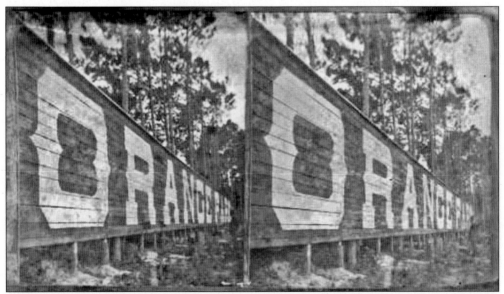

THE LARGEST SIGN IN AMERICA. Measuring 15 feet high and 200 feet long, this was advertised as the largest sign in America. The sign was located on the banks of the St. Johns River directly opposite of Mandarin so as to attract the attention of passengers aboard the steamboats. (Courtesy of Florida Photographic Archives.)

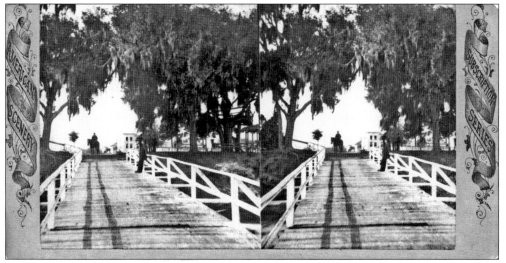

AT THE FOOT OF KINGSLEY AVENUE. In the trees to the right is the "Crow's Nest," a platform built about 15 feet off the ground and used for viewing the river. The Park View Hotel was farther to the right. The town's pier, pictured here, extended 1,440 feet into the St. Johns River. This length was required to reach the deep water needed by the steamboats.

RIVER ROAD C. 1879. Shortly after the town was created by Florida Winter Home and Improvement Co., a series of stereoscopic views was created to help advertise the town. The series contained 24 views and could be purchased for $3.25. This view is number 20 in the series. Today River Road runs parallel to the St. Johns River.

KINGSLEY AVENUE.
Named for Zephaniah
Kingsley, this is the
main road running
from east to west
through town. It was
once lined with oaks
and magnolias.
(Courtesy of Florida
Photographic Archives.)

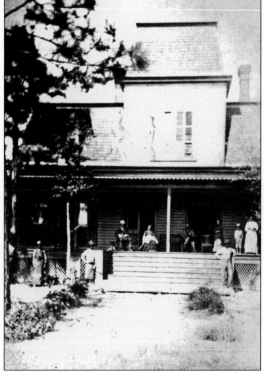

**THE WINTER HOME OF BENJAMIN F.
STILES.** Stiles first visited Florida in 1869
for his health. He returned every year
until 1872 when he purchased 60 acres of
riverfront land and moved permanently
to Orange Park. By 1885 he had a 30-acre
orange grove containing 2,300 trees.
Stiles was mayor of Orange Park for
several terms. (Courtesy of Florida
Photographic Archives.)

VIEW OF FULL BEARING ORANGE TREE FROM OLD PLANTATION C. 1879. Named Orange Park because of the extensive orange groves, the town suffered a major setback when most of the citrus trees were severely damaged in the freeze of 1895. This freeze forced many of the grove owners to shift their interest further south. This is view number three from the Florida Winter Home and Improvement Co.'s stereoscopic series.

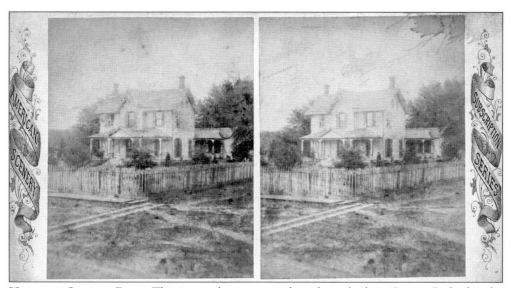

HOUSE IN ORANGE PARK. This image shows a typical residence built in Orange Park after the town was first incorporated. Several families who made annual winter trips to Florida built winter residences. After a few years many decided to move permanently to Florida. (Courtesy of Matheson Museum.)

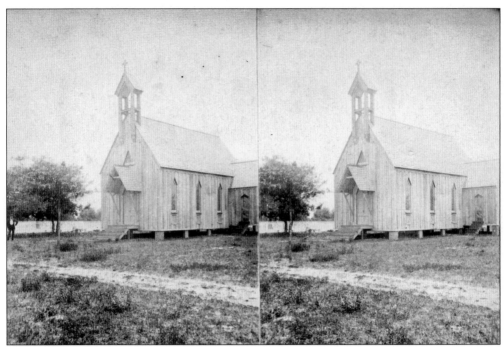

GRACE EPISCOPAL CHURCH C. 1879. Pictured here one year after its construction, the church still meets today, although much of the original structure has been incorporated into a newer structure. (Courtesy of Matheson Museum.)

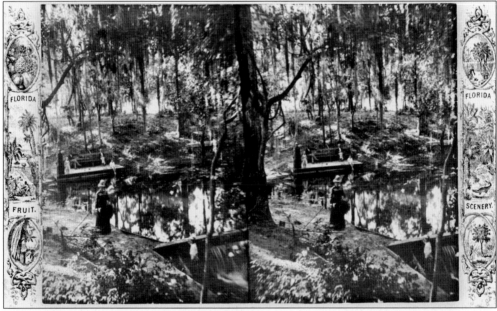

"BOILING SPRING." Known as Wadesboro Spring and Tululu Springs, this spring did not garner much attention from visitors, as it was a little over a mile out of town. Today over 2,000 gallons a minute is discharged from the spring, located at the front of a housing development appropriately called "The Springs."

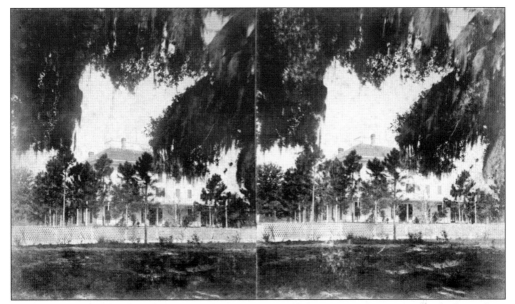

PARK VIEW HOTEL. Built in the early 1880s, the hotel drew many famous individuals, such as Harriett Beecher Stowe, President Grant, Chief Sitting Bull, and Buffalo Bill. In 1951 the hotel was torn down.

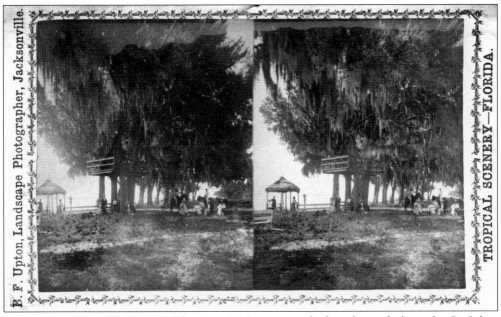

CROWS NEST BY B.F. UPTON. The Crow's Nest was a platform located along the St. Johns River in front of the Park View Hotel. From the platform the guest could enjoy the view of the river and watch the steamboats as they transported passengers to various stops along the river.

PRESIDENT U.S. GRANT'S VISIT IN JANUARY 1880. Grant and wife, along with a small entourage including Gen. and Mrs. Phil Sheridan, arrived in Florida on January 5, 1880, heading for a tour of Mexico. When he arrived, standing on the bow of the steamer with a cigar, exclamations such as "There he is!", "That's Grant!", "Where?", and "Show him to me!" were heard to be said. In the end one sightseer could not see what there was about that man to make

a fuss about. In Jacksonville, Grant, along with several hundred admirers, took a short pleasure cruise aboard the *Sappho* on the St. Johns. As they traveled all the steam sawmills saluted the party by blowing their whistles. On January 8 they boarded the steamer *George R. Kelsey* and headed for Palatka, making a stop at Orange Park.

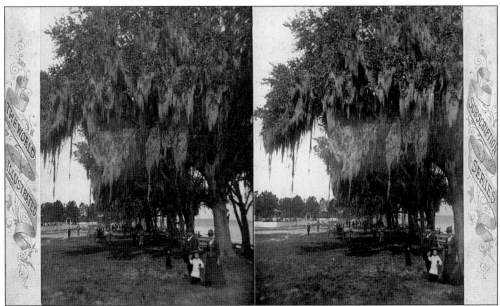

SCENE ALONG THE ST. JOHNS RIVER. When Orange Park was formed, the planners created a waterfront of over five miles. Just beyond the fence to the left is the Park View Hotel. The Crow's Nest is located in the center of the trees. The road along the river was 50–100 feet wide.

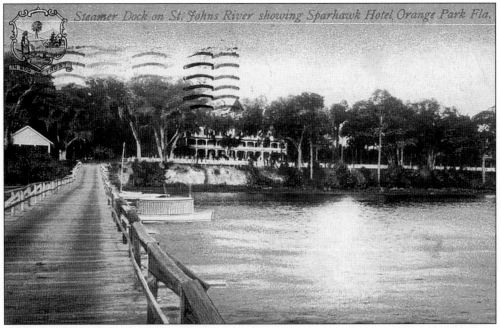

THE SPARHAWK HOTEL C. 1910. By the turn of the century the number of guests at Park View Hotel had shrunk considerably. A new owner changed the name of the hotel to the Sparhawk. Many local residents visited the hotel to enjoy a nice dinner on the weekend. Orange Park's 1,440-foot pier was located directly in front of the hotel.

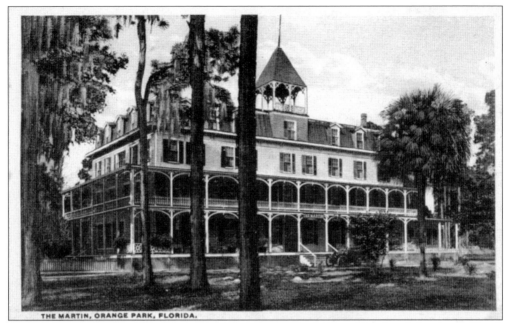

THE MARTIN HOTEL. The Martin Hotel was the old Park View Hotel and Sparhawk Hotel. This was the last attempt to keep the building a hotel. In the 1920s the Loyal Order of Moose purchased the building and the members used it as their temporary residence.

KINGSLEY AVENUE C. 1907. The writing claimed that this was "the finest live oak avenue in Florida." Today a small portion of the road retains some large oaks. Since the wharf was at the foot of Kingsley Avenue, many tourists were thrilled to see the large oaks with the moss swaying in the breeze. Notice the pig near the third tree on the right.

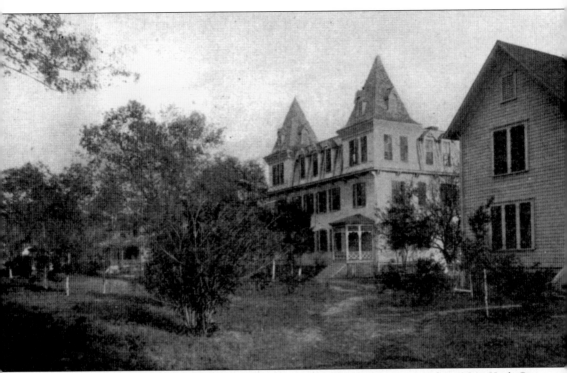

ORANGE PARK NORMAL SCHOOL. The American Missionary Association from New York City first started the school for African-American youths in 1895. The campus contained nine acres and on the grounds were two dormitories, a school building, dining hall, laundry, church, workshop, and other buildings. On April 26, 1912, the church was destroyed by fire. By 1912 the school consisted of 16 boys and 26 girls boarding plus 36 local students. The school taught 1st through 12th grades. Tuition for grades one through eight was 50¢ a month while 9th through 12th grades was $1 per month. Those boarding were required to attend a Sunday church service and no visitors or business transactions were allowed on Sunday. The faculty consisted of seven teachers with Rev. George B. Hurd serving as the principal and acting pastor. The buildings pictured here from left to right are the girls' dormitory, Hildreth Hall, and the boys' dormitory. (Courtesy of Clay County Archives.)

Three

HIBERNIA

Hibernia/Fleming Island is situated on a tract of land along the St. Johns River seven miles south of Orange Park. George Fleming petitioned Spanish governor Enrique White for 1,000 acres along the river and on January 11, 1800, Governor White granted Fleming's petition. The family continued to live in Hibernia, periodically defending their property against raiding Indians and Americans during the Patriot Rebellion of 1811–1812. When the Civil War came to Florida, all of the Fleming men enlisted in the Confederate Army. The oldest, Charles Seaton, who rose to the rank of captain in the 2nd Florida Infantry, was killed at Cold Harbor, Virginia, in 1864. Francis served as an officer in the 1st Florida Cavalry and was elected governor in 1889. After the war Margaret opened their house to guests traveling along the river. Soon travelers became more frequent and the Flemings built a guest cottage and opened a boarding house for winter tourists as steamers from Jacksonville made three daily stops here. The Flemings were described as "educated Southerners" but "impoverished by the war." On November 4, 1872, 38 citizens petitioned the county to construct a public road between Green Cove Springs and Hibernia. On January 7, 1878, a road was approved to cross Black Creek and connect with Middleburg Road, evidence that the county was growing from tourism. In 1878 an Episcopal church was built in honor of Margaret Fleming, who died the year before. Margaret had helped to establish a Methodist Episcopal church for the African Americans in the area. By 1931 the area had lost many of its residents, and the post office, which had been established in 1849, was moved to Green Cove Springs.

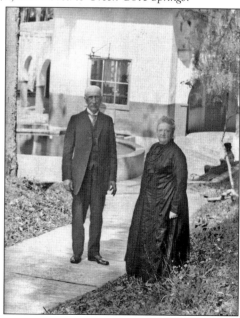

THE FLEMINGS. Frederic A. Fleming and his wife Margaret are pictured at Green Cove Springs. (Courtesy of Matheson Museum.)

CHAS. POLLOCK, Boston, Mass., Publisher.

No. 1. St. John's River, with reflection. A.

THE ST. JOHNS RIVER WITH REFLECTION BY C. SEAVER JR. Charles Seaver Jr. was a prolific photographer from Boston who produced series of stereoscopic views of exceptional quality that exhibited sharp detail and interesting subjects. Seaver, along with George Pierron from St. Augustine, helped to form the "Florida Club," a group of photographers who published views of St. Augustine for the tourists. Seaver traveled the St. Johns River during the late 1860s and early 1870s producing several series of views from Jacksonville to Silver Springs. Three of his series—Hibernia, Magnolia, and Green Cove—are from Clay County. These series were available to the tourists who came to visit the area. The several views that follow are almost the entire series from Hibernia. There were 18 different views of the resort. While the Flemings did not run a large resort, approximately 35 guests, many lavish praises were bestowed upon them. (Courtesy of Matheson Museum.)

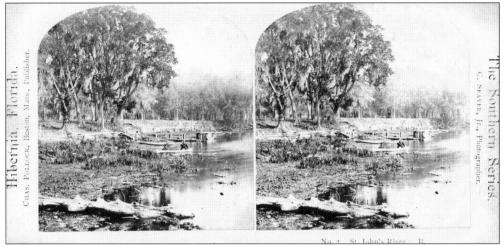

THE *ST. JOHNS RIVER* BY C. SEAVER JR. The St. Johns River is one of only three rivers in the United States that flows south to north. Originating near Sebastian, it flows north for 310 miles, gradually dropping an inch a mile before it flows into the Atlantic Ocean at Mayport. In 1998 the river was designated an American Heritage River. (Courtesy of Matheson Museum.)

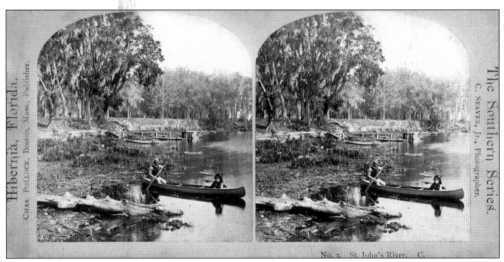

CANOEING ALONG THE BANKS OF THE *ST. JOHNS* BY C. SEAVER JR. The Flemings, like other hoteliers, provided a few small boats that could be rented for recreation. Since Hibernia was located very near the mouth of Black Creek, many tourists explored the banks of the creek.

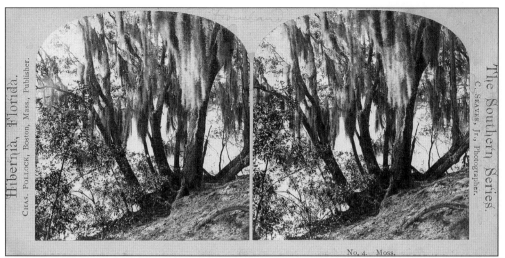

Moss by C. Seaver Jr. The Spanish moss that grew from the trees was a curiosity to the Northern travelers. One such traveler described the moss-covered trees as looking "wonderfully grand draped in the weird gray moss."

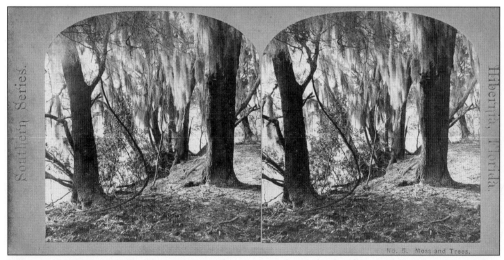

Moss and Trees by C. Seaver Jr. After it was cleaned of redbugs, the moss was used as stuffing for beds. The moss so enamored the visitors that they inquired of Frederick Fleming as to the harm it caused the tree. He replied that the moss did "not destroy the foliage any more than a shaving would do."

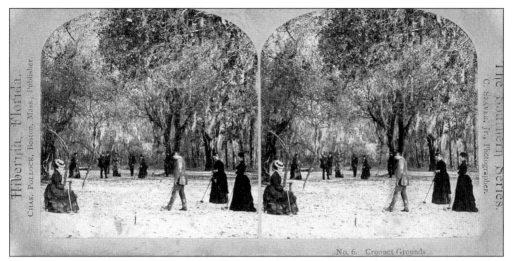

CROQUET GROUNDS BY C. SEAVER JR. Croquet became very popular in the United States when it was first introduced around 1861. By 1867 the game was fast becoming very popular, as it was one of the few outdoor games that could be enjoyed by both sexes. The sport was popular "especially with the ladies," as one New York newspaper wrote.

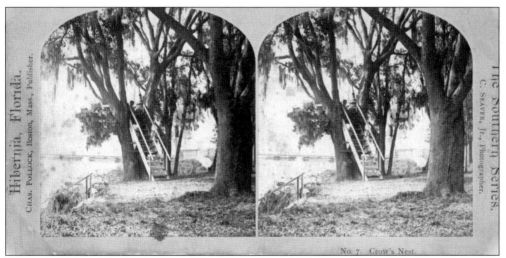

CROW'S NEST BY C. SEAVER JR. Hibernia, like Orange Park, offered a viewing platform nestled in oak trees for the tourists to view the St. Johns River. One visitor wrote "the outlook across the river is beautiful." One might well spend the day basking in the warm winter sunshine watching the wildlife engage in their daily way of life.

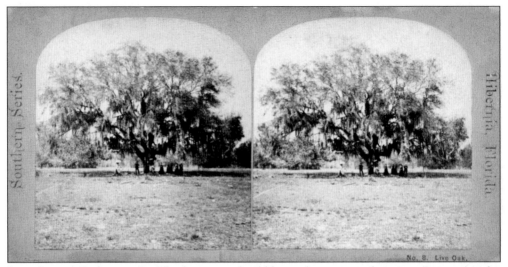

LIVE OAK BY C. SEAVER JR. The large, stately old live oaks captivated visitors. On a particular trip a visitor wrote that the Flemings showed her one such tree whose "branches spread forty or fifty feet on every side." The live oaks were highly prized for their lumber, which was used in sailing ships.

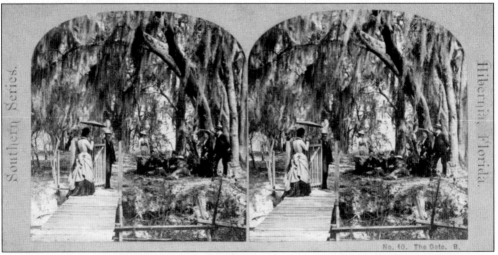

THE GATE BY C. SEAVER JR. This was the most photographed spot in Hibernia. It led to one of the many paths that were available to walk during a warm winter day. Note that the group of people pictured here is the same standing under the live oak on the preceding image.

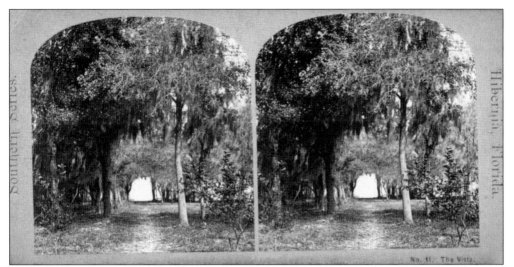

THE VISTA BY C. SEAVER JR. This was an oak-lined path leading to the St. Johns River. Notice the small orange tree in the front right. Though it could not compete against St. David's path in Green Cove Springs, it did offer the tourists a peaceful and relaxing walk around the grounds of the old plantation.

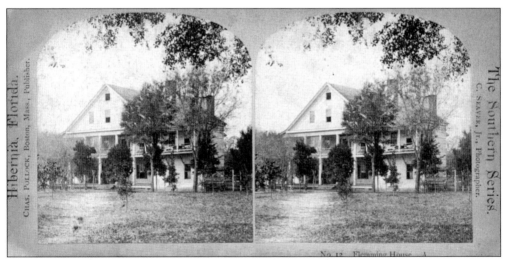

FLEMING HOUSE A BY C. SEAVER JR. In 1869 the house was described as a "spacious, overgrown New-England-appearing farmhouse, hid behind clustering trees and branches, on a pleasant and inviting spot." Those who chose to board here were very loyal, as they returned year after year. It was praised as a nice quiet spot and the accommodations were "homelike and comfortable."

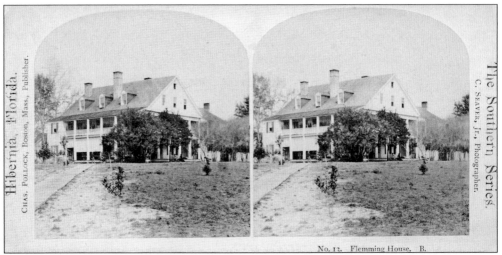

FLEMING HOUSE B BY C. SEAVER JR. This is the guest house that faced the river. Notice the small orange tree. The Flemings had started an orange grove and in 1885 a visitor claimed it was the "largest about the area." Frederick allowed the guests to pick oranges and many shipped the orange blossoms back home in a box. (Courtesy of Matheson Museum.)

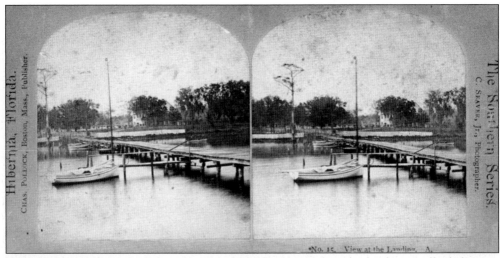

VIEW AT LANDING BY C. SEAVER JR. Since the hotel was near the landing it afforded guests the opportunity to gain passage on the many steamboats that plied the St. Johns River. Three times a day the steamboats made stops in Hibernia. The tall pole in the middle was used as a signal to indicate to passing steamboats that there was mail or passengers needing to be picked up on shore.

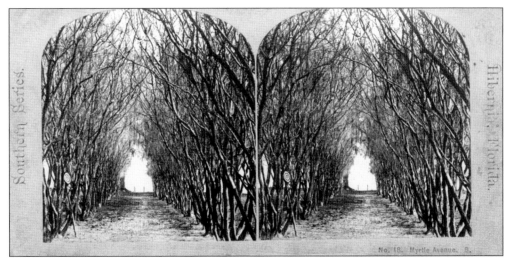

MYRTLE AVENUE BY C. SEAVER JR. This path led to the river and was another natural curiosity that thrilled visitors. Harriet Beecher Stowe, who visited Hibernia in March 1872, wrote, "there is something certainly very peaceful and attractive about its surroundings."

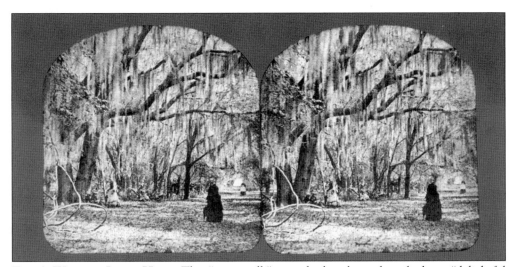

FRED'S WALK BY ISAAC HAAS. This "river-walk" near the hotel was described as a "delightful promenade about three-fourths of a mile under the spreading branches of noble live oaks." Guests could delightfully stroll down the path listening to the songs of the birds as they announced the arrival of spring.

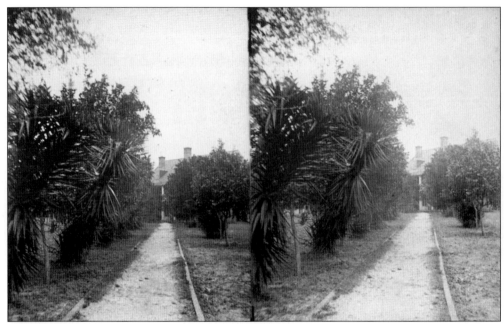

THE FLEMING HOUSE IN 1883. The rate was $15 a week or $2.50 a day, which was considerably less than the larger hotels at Magnolia and Green Cove Springs. It was not uncommon for the Flemings to have to turn away guests because they had no rooms available. Notice the growth of the vegetation as compared to those pictures taken by Charles Seaver Jr.

PAWPAW TREE BY A.G. GRANT. The Pawpaw tree grows the largest edible wild fruit and the tree can grow as far north as the Great Lakes. Some people say the taste of the fruit is a cross between an apple and a banana. Most remember the name of the tree from the rhyme of "Where, oh where, oh where is Susie? Way down yonder in the pawpaw patch. Pick up pawpaw; put 'em in a basket." (Courtesy of Matheson Museum.)

Four

MAGNOLIA SPRINGS

Magnolia Springs was located just north of Green Cove Springs on the banks of the St. Johns River. The property was first known as "Constantia" when it was owned by several different families, the first being Daniel O'Hara's. Dr. Nathan Dow Benedict, superintendent of the New York State Insane Asylum, moved to Magnolia around 1851 so he could recover his failing health. Never returning to New York, he created a small hotel that later helped to launch the "Saratoga of the South"—Magnolia Springs Hotel. During the Civil War, Union troops created a small camp that included an earthenwork fort. From here the Yankees would send out small raiding parties to harass Confederate sympathizers located in the interior of the county. When the war drew to a close the Union government created a hospital and refugee camp for the recently freed slaves, and Dr. Benedict was gainfully employed by the federal government as a physician in Magnolia. Tired of the political climate when the Union Army left Magnolia, Dr. Benedict moved to St. Augustine, where he took charge of the Army General Hospital. When Dr. Benedict took residence in St. Augustine he sold his property to Seth Rogers and Oliver Harris, who quickly remodeled and expanded the accommodations to allow about 100 guests. It was Rogers and Harris who made Magnolia Springs the grandest resort in Clay County. Needing more by 1872, several cottages were erected by Seth Rogers and Oliver Tracey. When Isaac F. Cruft of Boston decided to build a larger hotel in Magnolia he tore down the hotel built by Rogers and Harris but kept the cottages, which he remodeled with all the latest conveniences. In 1881 Cruft opened his Magnolia Springs Hotel, which soon became one of the grandest hotels on the St. Johns River.

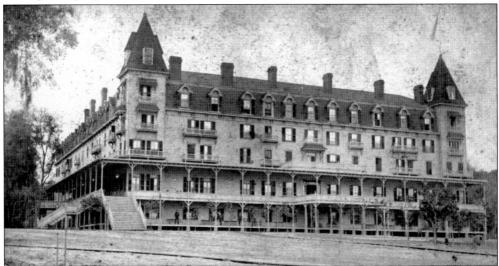

MAGNOLIA SPRINGS HOTEL. This picture, c. 1890, shows the hotel after it had been opened for a few years. This is the new Magnolia Springs Hotel that was built in 1881.

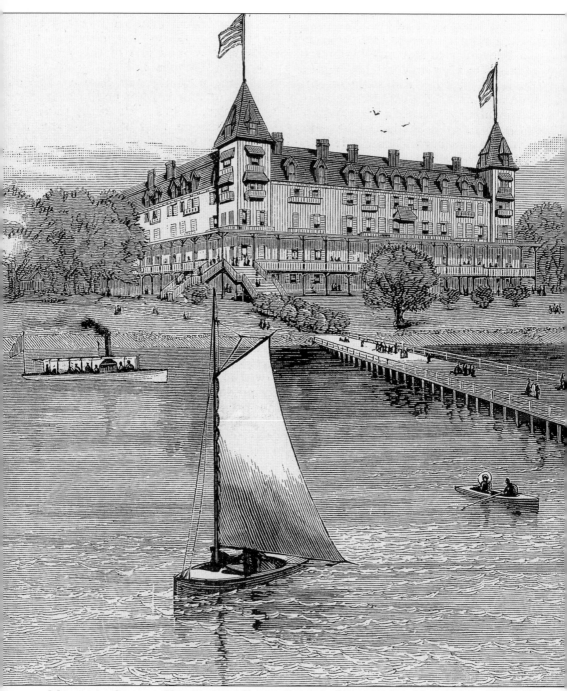

MAGNOLIA SPRINGS HOTEL FROM *FRANK LESLIE'S ILLUSTRATED NEWSPAPER*. The hotel provided first-class accommodations and was one of the finest hotels along the St. Johns River.

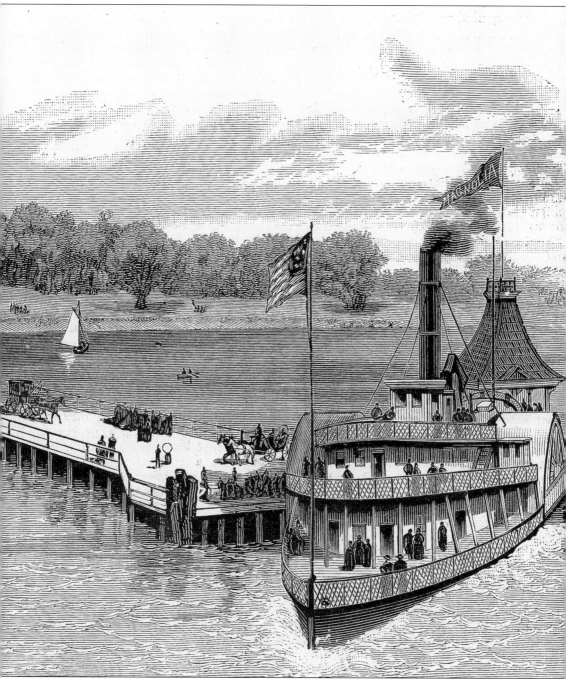

Along with the six cottages stretched along the river, the hotel could boast of 810 rooms. The weekly rate was $28. The hotel was usually open from late December until May.

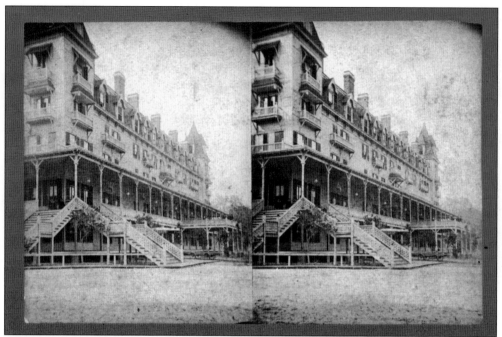

MAGNOLIA SPRINGS HOTEL BY UPTON. The new Magnolia Hotel was built in 1881 by J.A. McGuire. The main building consisted of four floors with a broad piazza extending along the first and second floors. The building measured 175 feet across the front with a wing extension of 228 feet. Both portions were 42 feet wide.

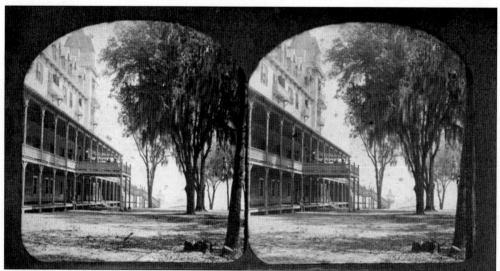

MAGNOLIA SPRINGS HOTEL LOOKING EAST. During the winter afternoon the porches and verandas were filled with relaxing guests. The ladies would pass their time by chatting and working embroidery while the gentlemen would read the newspapers and smoke. The hotel offered a first-class dinner, and after dinner guests would enter the parlors, where they could enjoy piano playing, singing, and games of charades.

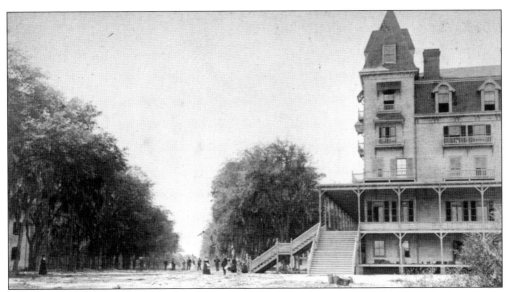

MAGNOLIA SPRINGS HOTEL BY J.S. MITCHELL. The hotel was first managed by A.C. Colman. Other managers were William F. Ingold and O.D. Seavey. The upper floors were devoted to the 240 guests' sleeping rooms. The first floor contained the billiard room, storerooms, and sleeping quarters for the employees. The second floor contained the office, parlors, reading and writing rooms, and a large, well-lit dining room.

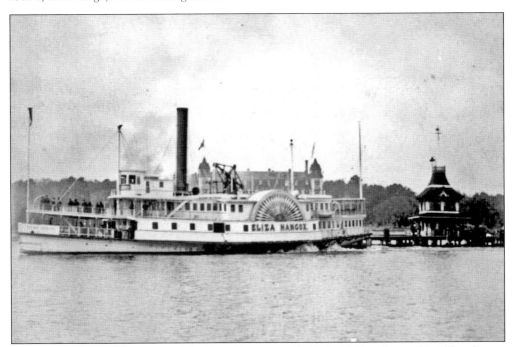

ELIZA HANCOX AT MAGNOLIA. The *Eliza Hancox* was built in 1863 at Jersey City, New Jersey, and was soon thereafter contracted out to the Quartermaster Department. She was 153 feet in length and 27 feet wide. It was not until December 1880 that the *Eliza Hancox* began making runs along the St. Johns River during the winter tourist season. (Courtesy of Florida Photographic Archives.)

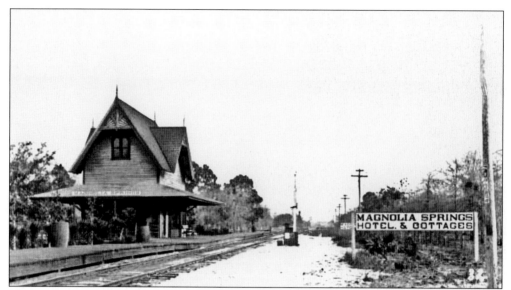

MAGNOLIA SPRINGS DEPOT. The railroad depot was on the Jacksonville, Tampa, and Key West Railroad. This line started operation in 1884 and quickly proved to be more popular than travel by steamboat. A mule-drawn cart on a small rail line ran from the depot to the hotel to help transport guests. (Courtesy of Florida Photographic Archives.)

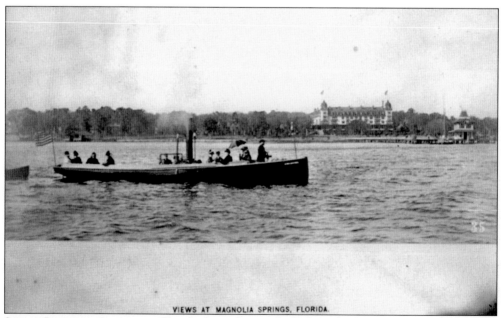

STEAM-LAUNCH ANEMONE. This little craft was docked at the hotel, as one guest wrote, "to tempt excursionists." The craft could hold about a dozen people and it plied the St. Johns River to take guests to Six Mile Creek or Black Creek. A short excursion would cost around $10 and an awning was provided to shield the guests from the sun. (Courtesy of Florida Photographic Archives.)

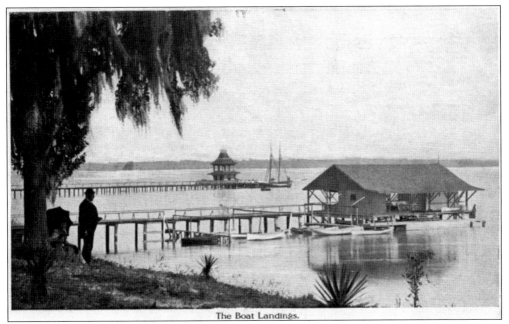

The Boat Landings.

THE BOAT LANDINGS. The landing was large enough to accommodate the largest steamships that ran on the river. The pier extended 600 feet into the river and a two-story pagoda stood at the very end. On the second floor a band would greet the guests arriving and departing. A mule-drawn cart ran to the end of the dock to help convey guests to the hotel.

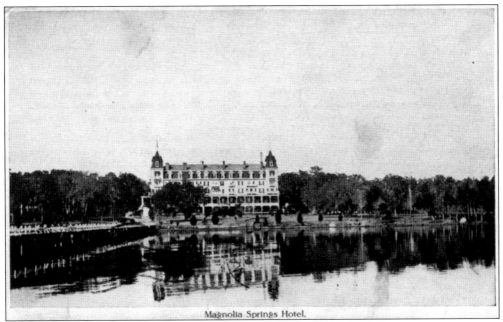

Magnolia Springs Hotel.

MAGNOLIA SPRINGS HOTEL FACING THE ST. JOHNS RIVER. The hotel was built 90 feet from the river on a small hill allowing guests a magnificent view of the river from their rooms. The location was advertised to be free from the morning dampness and it had an "absolute immunity from mosquitoes."

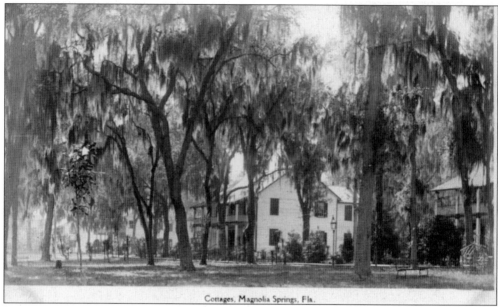

Cottages, Magnolia Springs, Fla.

COTTAGES AT MAGNOLIA SPRINGS HOTEL. Originally six cottages were located adjacent to the hotel, each facing the river. Each room was decorated in lavender and pink and consisted of a bedstead bureau with desk interior, commode table, and four chairs, cane rocker, bed with moss mattress, two feather pillows, five sheets and blankets, towels, health brush, two curtains and fixtures, wood box, lamp, and a match safe. These cottages were the only buildings remaining from the first Magnolia Hotel

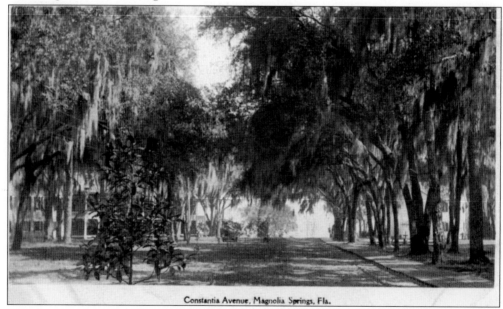

Constantia Avenue, Magnolia Springs, Fla.

CONSTANTIA AVENUE. This was the only road in Magnolia and it was named after the original plantation that had been established by Daniel O'Hara on land purchased from William Travers. The road led to the railroad depot. On the left is the hotel and on the right is the first cottage facing the river. Each cottage was connected to the lobby of the hotel by an electric wire that was used for communications.

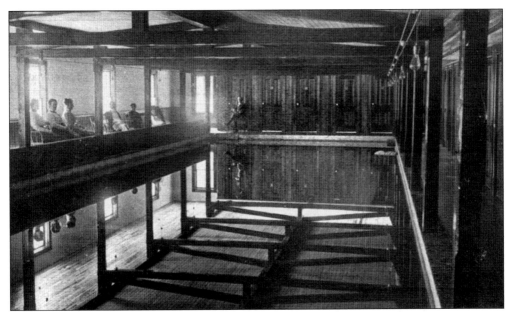

THE SWIMMING POOL. The pool at the hotel measured 20 by 63 feet with a depth graduated from three to seven feet. Adjoining was a large shower-bathroom connecting to a dressing room. The pool was filled from a spring located on the hotel property.

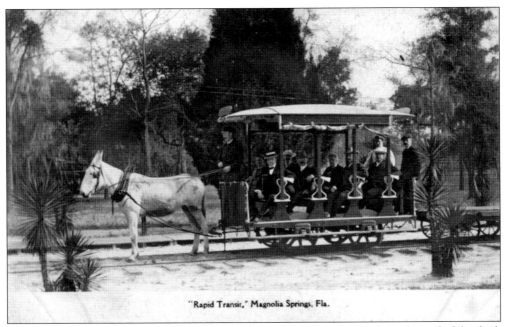

"Rapid Transit," Magnolia Springs, Fla.

"RAPID TRANSIT" AT MAGNOLIA SPRINGS. This mule-drawn cart ran from the end of the dock to the railroad depot on the Jacksonville, Tampa, and Key West rail-line. One guest wrote in 1888 that the mule "exhibits a great deal of reluctance about starting until you have given the driver a quarter."

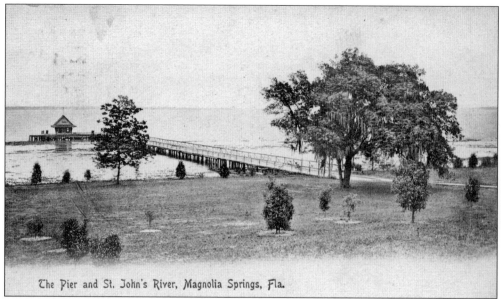

The Pier and St. John's River, Magnolia Springs, Fla.

THE PIER AND THE ST. JOHNS RIVER. Between the pier and hotel lay an open, well-manicured ground. The hotel had started a small orange grove with no success. One traveler remarked that the soil was nothing but sand and "one might easily imagine himself on the sea shore." (Courtesy of Matheson Museum.)

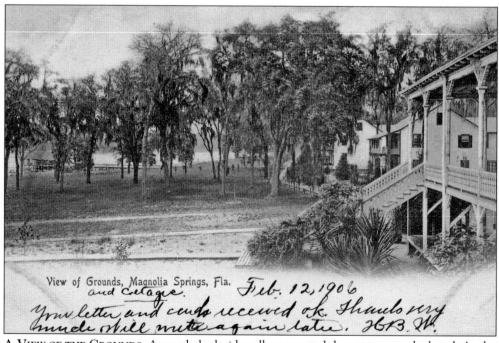

View of Grounds, Magnolia Springs, Fla.
and Cottage.

Feb. 12, 1906

Your letter and cards received ok. Thanks very much. Will write again later. JKB. W.

A VIEW OF THE GROUNDS. A wood plank sidewalk connected the cottages to the hotel. At the end of the sidewalk a path led to Green Cove Springs. To delight the guests, the hotel tried to provide tropical foliage and in March 1885 a large strawberry garden was growing. (Courtesy of Matheson Museum.)

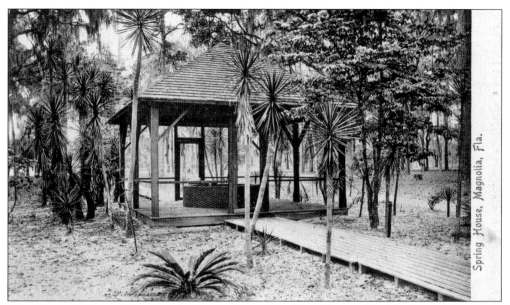

The image has the caption "Spring House, Magnolia, Fla." printed vertically on its right edge.

THE SPRING HOUSE. The springhouse was located within a few yards of the hotel. The spring was said to yield an "unfailing supply of water whose remarkable purity and health-giving proprieties are amply provided by the analysis of Professor C.H. Chandler, of New York, and the wonderful benefits derived from its use by patrons of the hotel and people from near and far who drink the bottled water." (Courtesy of Matheson Museum.)

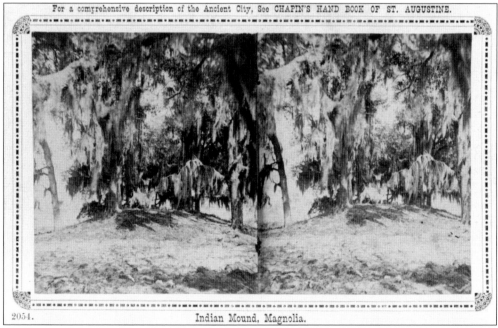

For a comprehensive description of the Ancient City, See CHAPIN'S HAND BOOK OF ST. AUGUSTINE.

2054. Indian Mound, Magnolia.

AN INDIAN MOUND. The Timucua tribe inhabited North Florida for many centuries prior to the arrival of Spanish soldiers in the 16th century. It is thought that Clay County was a buffer zone between the Utina tribe located to the south and the Saturiwa tribe located to the north. Artifacts representing the St. Johns I and II cultures (500 B.C.–1565) and the Alachua culture (600 A.D.–1539) have been found in the area.

49

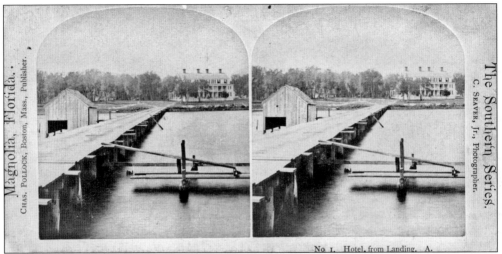

HOTEL FROM LANDING BY C. SEAVER JR. Dr. Seth Rogers and Oliver F. Harris purchased the hotel from Dr. Nathan Benedict just after the end of the Civil War. Rogers and Harris greatly improved the buildings by enlarging them and furnishing them with new, quality furniture. With the remodel the hotel could accommodate about 100 guests. (Courtesy of Matheson Museum.)

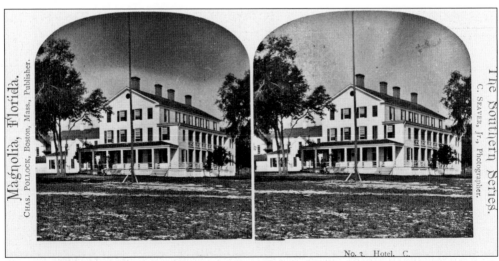

MAGNOLIA HOTEL BY C. SEAVER JR. This view shows the newly remodeled hotel that was built in 1851. The hotel was originally built with "special reference to the wants of invalids, and their treatment under medical supervision." During the Civil War it was used by the U.S. military for various purposes and was greatly damaged. (Courtesy of Matheson Museum.)

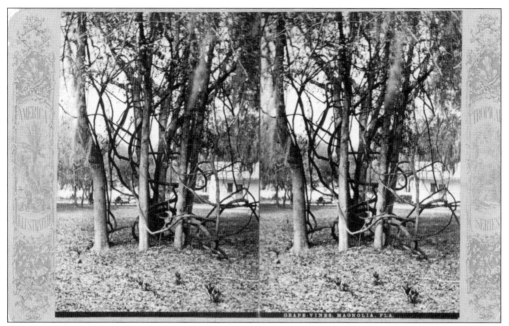

GRAPE VINES. Anything natural that drew curiosity became an agreeable subject to photograph. These grape vines are rather large and really show well because of the loss of leaves in the winter. Notice in the image below that the same set of trees and grape vines were used as a backdrop.

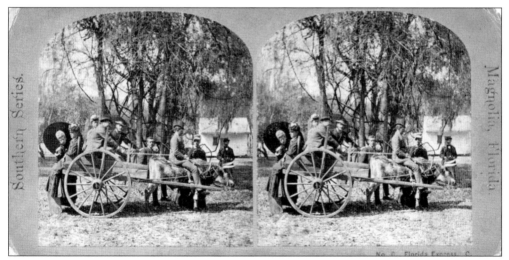

FLORIDA EXPRESS BY C. SEAVER JR. The Northern tourists marveled at the simplicity of the local transportation and gladly paid a few quarters to have their picture taken on such an elegant mode of transportation. These carts were ideal to travel the sand roads that had been newly created in Clay County.

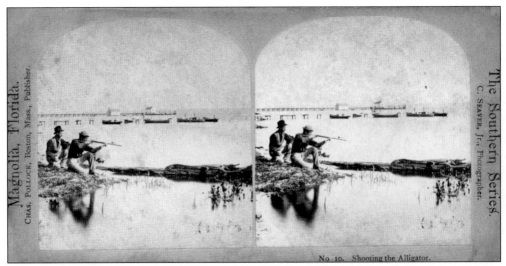

SHOOTING THE ALLIGATOR BY C. SEAVER JR. While quail, turkey, and deer hunting were offered by the hotel, all wished to hunt alligator. This particular event appears to be staged, as there seems to be something propping the alligator's mouth open and the shooter appears not to have his finger on the trigger.

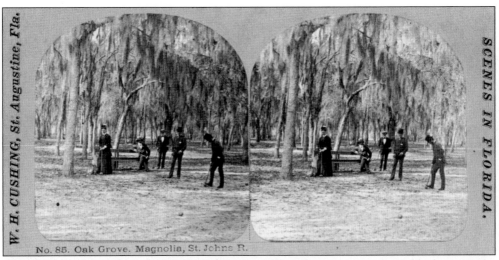

OAK GROVE, MAGNOLIA BY W.H. CUSHING. Although croquet was quickly becoming a popular sport, the hotel could also boast a nine-hole golf course. The course ran for one and a half miles and an annual tournament was held in early March. In 1909, $147.50 worth of silver trophy cups was ordered from the John Frick Jewelry Co. in New York City for the winners of the tournament. The croquet lawn was located behind the hotel.

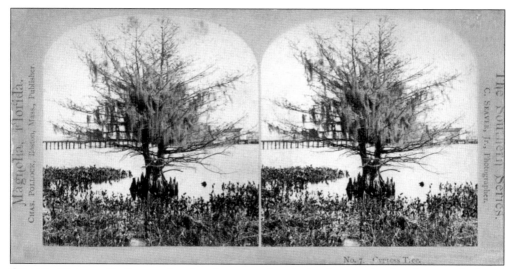

CYPRESS TREE BY C. SEAVER JR. Another natural curiosity that caught the photographer's eye was this lonely cypress tree covered with moss in the winter. The dock in the background was torn down when the new hotel was built.

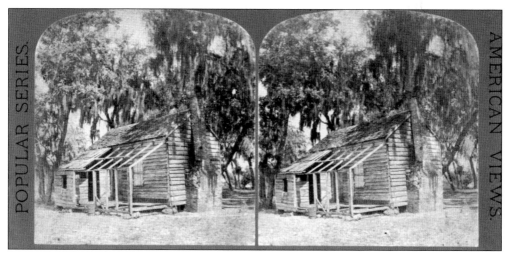

SUBJECT FOR RECONSTRUCTION BY E. AND H.T. ANTHONY. Because residents had lived in Magnolia since the first half of the 19th century, there were some houses that no longer were occupied by this time. The material and construction method on the building pictured here suggests that it was built in the first half of the 19th century.

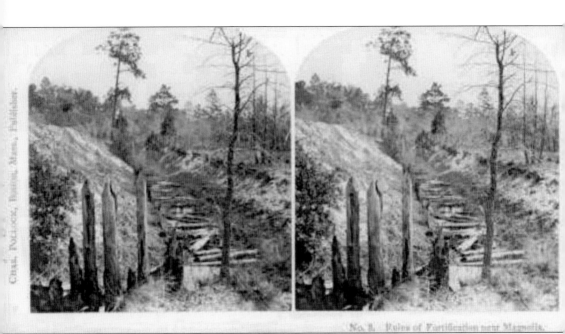

Ruins of Fortifications near Magnolia by C. Seaver Jr. The Union Army had hopes of strengthening their forces and demoralizing the local inhabitants when they established a post at Magnolia. The actual effects were just the opposite of what the federal troops had hoped. In every case the federal cavalry met with defeat, and on October 24, 1864, the largest battle in Clay County occurred. Elements of Confederate cavalry under the command of Capt. J.J. Dickison attacked a detachment of the 4th Massachusetts Cavalry. The result was a complete route of the federal forces, who retreated into the swamps and made their way back to Magnolia. Brig. Gen. John P. Hatch, who commanded the District of Florida, was berated by his superiors because of his establishment of a fort at Magnolia. Maj. Gen. J.G. Foster wrote, "Cavalry raids in Florida, so far have resulted in no benefit to the Government. In fact, they have only resulted in furnishing the rebels with fine arms and horses." The fort pictured here was constructed in September 1864. On November 4, 1864, Magnolia was abandoned because the "military position at Magnolia was very faulty . . . the site, being flat and covered within musket range of the fort with woods, would enable the enemy to approach under cover and unobserved. The bend of the river shore presents two prominent points, above and below the landing-place, from which batteries erected by the enemy may drive off the gun-boats and keep the garrison in a state of siege until it surrenders." (Courtesy of Florida Photographic Archives.)

Five
GREEN COVE SPRINGS

Green Cove Springs was fast becoming a winter resort town by the time it incorporated on November 2, 1874. Although the area had been referenced during the British period (1763–1784) as an ideal spot for a rice plantation, the area remained sparsely populated until the Civil War. Building upon Dr. Nathan Benedict's successful hotel at Magnolia, several men, including Joseph W. Applegate, John S. Harris, and Theodore T. Edgerton, invested in the construction of winter resort hotels. It was from these hotels that the town grew. In 1870 the population was 250, but by 1884 the town's population was quickly approaching 1,000 inhabitants—a sizable amount considering the county's entire population in 1880 was 2,838. In 1885 the town was described as an "honest community" with "peaceful and industrious" citizens. It could boast of five churches, four schools (two private), several large winter hotels, numerous boarding houses, and a weekly paper, The Springs, which was started by N.B. Clinch in December 1880. When the Jacksonville, Tampa, and Key West Railroad line opened, it enabled tourists to travel from Jacksonville to Green Cove Springs in about an hour, and this mode of transportation soon became popular. When men like Henry Plant and Henry Flagler built their railroads and hotels they started to draw the tourists away from the riverboats, and many of the hotels closed because they could not compete against the larger hotels in St. Augustine and Tampa. Throughout the 20th century the growth of Green Cove Springs remained steady. In the 1950s the navy built a large base for a mothball fleet, but the base did not remain long and the town's growth was severely hurt. Today Green Cove Springs remains the county seat as it has since it was moved there in 1871.

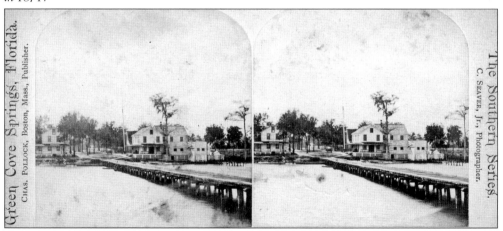

GENERAL VIEW FROM LANDING BY C. SEAVER JR. In the early 1870s the town was just beginning to expand as the winter hotels started to become successful. Tourists must have been surprised by the relative sparseness of the town when they walked down the dock at the town's landing. (Courtesy of Matheson Museum.)

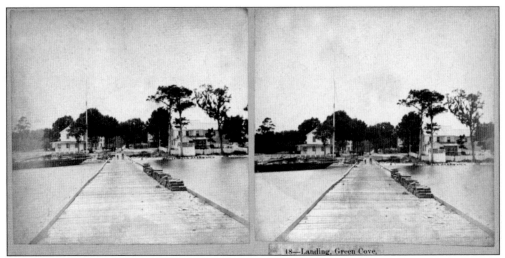

LANDING BY WOOD AND BICKEL. The general landing for the town was located at the foot of Walnut Street. The building to the right is a general store that sold fruits and tobacco. Further up the road on the same side was a curio shop and Isaac Haas's photography shop. The building on the left is unknown, and the tall pole in front was used to signal passing steamboats.

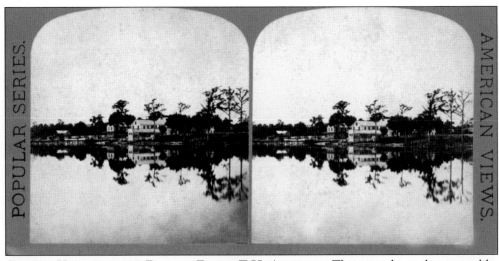

GENERAL VIEW FROM THE DOCK BY E. AND T.H. ANTHONY. This view shows the mirror-like quality of the river that dazzled the tourists. R.C. Reed's cottage can be seen at the far left. Just out of view on the far right would be the Riverside Cottage.

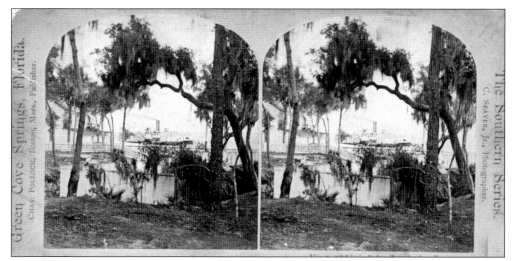

LIZZIE BAKER *AT THE LANDING* BY C. SEAVER JR. The *Lizzie Baker* made four trips a week from Jacksonville to Palatka. Built in 1864 in East Albany, New York, she was 170 feet in length and 29 feet wide. On January 11, 1875, she wrecked on the St. Johns River.

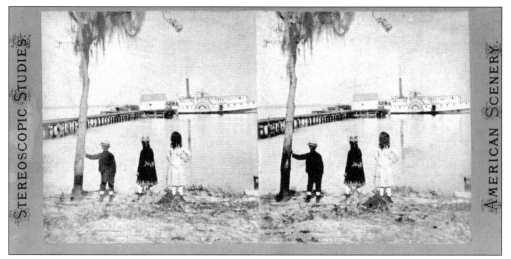

STEAMER FLORENCE *AT LANDING* BY C. SEAVER JR. The *Florence* was built in 1869 in Wilmington, Delaware. She was 135 feet in length and 24 feet wide. Her owner, Captain Brock, was a successful businessman who ran several steamers along the St. Johns River. The *Florence* made a daily runs from Jacksonville to Palatka.

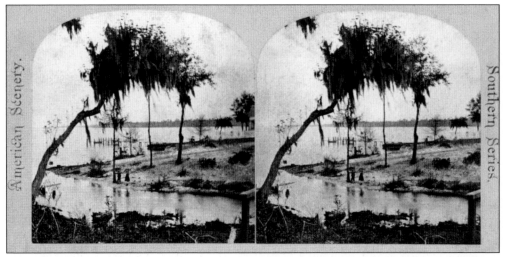

SPRINGS OUTLET. This view was taken from the original footbridge that spanned the spring's run. By 1897 the first footbridge was reported as being dilapidated and was no longer in use, although it was still standing. A small portion of R.C. Reed's cottage can been seen at the far right.

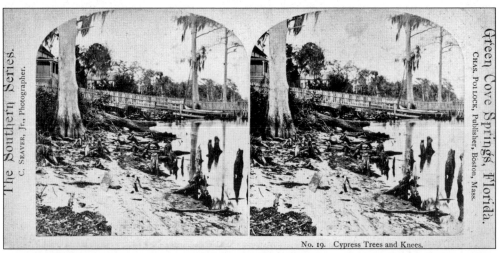

No. 19. Cypress Trees and Knees.

CYPRESS TREES AND KNEES BY C. SEAVER JR. Because the wood of the cypress is generally resistant to decay, it was highly sought after for its lumber for use in houses. Not only is the wood easy to work with relatively few hand tools, but its rich color and grain also make beautiful cabinets and furniture. (Courtesy of Matheson Museum.)

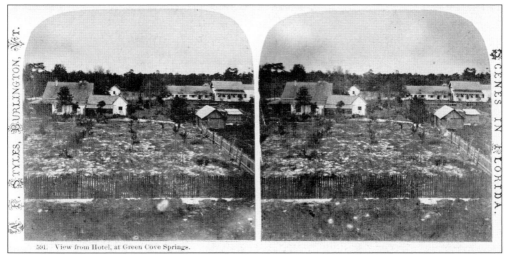

VIEW FROM HOTEL BY A.F. STYLES. Adin F. Styles traveled through Florida in 1869–1870. He was one of the first photographers to photo-document the budding resorts along the St. Johns River. This image was most likely taken from the Union Hotel, which was later renamed the St. Clair Hotel. (Courtesy of Matheson Museum.)

SPRING STREET. The building on the left is Smith's Cottage, and one of the cottages from the Clarendon Hotel can be seen faintly in the background. Spring Street offered a more scenic view and atmosphere than that of Walnut Street, only one block to the north. In this image the view is looking west. The image was possibly taken by Isaac Haas. (Courtesy of Matheson Museum.)

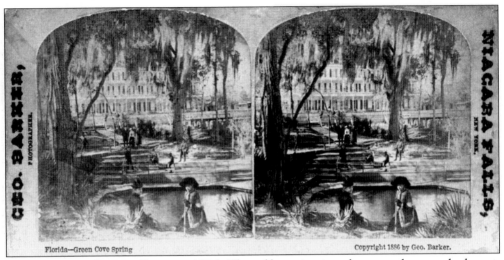

THE SPRING BY GEORGE BARKER, 1886. The sulfur spring was the most photographed scene in town since it was the main attraction. The water boils up from large fissures some 20 feet down at a rate of 3,000 gallons per minute. One tourist wrote, "it is as clear as a diamond, and the effect is most beautiful at noonday, when the sun shines directly into the springs."

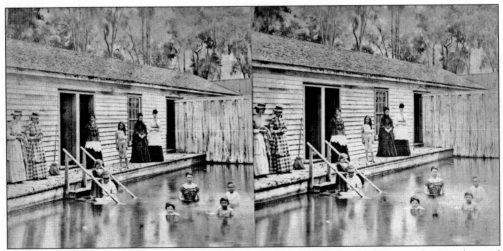

LADIES SWIMMING BY WILSON AND HAVENS. The swimming or bathing pools were located within a few feet of the spring's basin. There were two pools, each measuring about 25 feet wide and 75 feet long. Each had a row of dressing rooms on one side and some stairs descending into the water, which was about four feet deep. (Courtesy of Matheson Museum.)

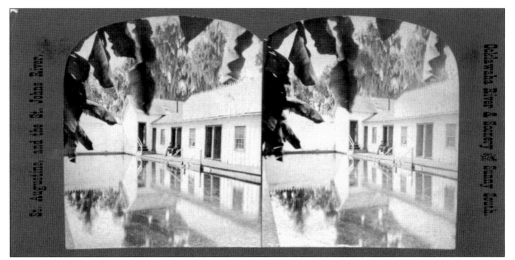

THE SWIMMING OR BATHING POOL. The second pool was divided up in order to provide a separate pool for the ladies and for private bathing. The temperature of the water year-round is about 78 degrees. With such warm water, the spring could be enjoyed throughout the year.

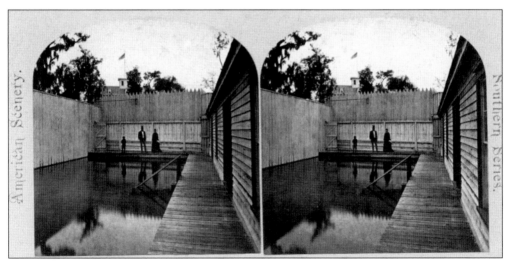

THE LADIES' SWIMMING BATH. The visiting women had a separate pool for their privacy. A tall fence surrounded each pool so as to not attract any unwanted visitors. If a lady did not know how to swim, Miss Smith could be hired for instruction, as she was the "obliging Manageress of the springs." The top of the Clarendon can be seen above the fence.

An Unidentified House in Green Cove Springs. This image represents one of many new homes that were constructed in town. When many of the annual Northern visitors decided to build their winter homes, large houses such as this were constructed. Lumber for these homes was readily available from the various mills on the St. Johns River and Black Creek.

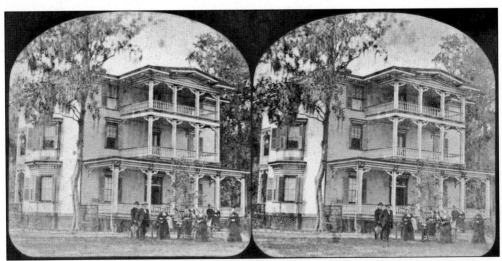

Thaddeus Davids's House. Mr. Davids, having spent winters in Green Cove Springs for many years, settled in town in the late 1870s. Originally from New York, he served as town mayor after incorporation. His house was located on the St. Johns River and had an extensive orange grove and garden. Thaddeus Davids owned and operated a large ink manufactory in New York. (Courtesy of Matheson Museum.)

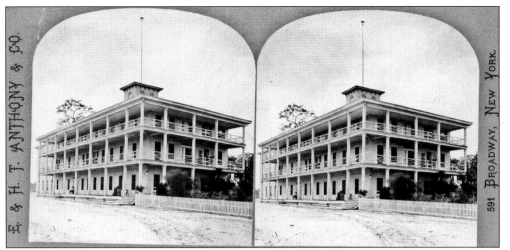

THE UNION HOTEL. This hotel was the first constructed by Dr. Joseph D. Mitchell just after the Civil War. In June 1866, Sarah A. Eaton purchased the property for $7,000. In 1869 the hotel could accommodate about 50 guests. It was described as "large and airy, but shockingly needs a coat of paint and some repairs." By 1873 the Union Hotel had fallen on bad times due to competition from the Clarendon Hotel and it was sold to Theodore T. Edgerton. (Courtesy of Matheson Museum.)

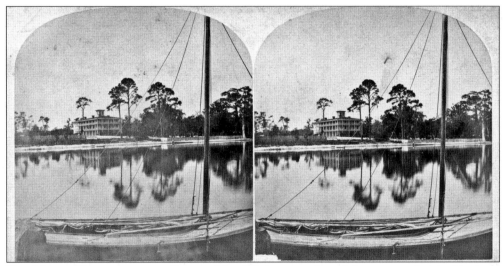

THE UNION HOTEL FROM THE RIVER. After Edgerton purchased the property he quickly made the necessary repairs to make the hotel first-class and called it the St. Clair. Although located three blocks north of the sulfur spring it boasted that "St. David's Path" originated at the lawn. In 1874 one tourist wrote that the hotel was just "far enough away from the spring to be out of the reach of the offensive sulfurous odors." For entertainment it could provide croquet, billiards, and a bowling alley. (Courtesy of Matheson Museum.)

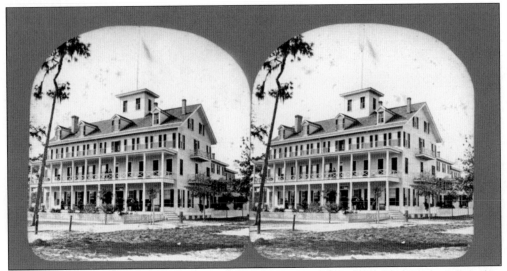

THE CLARENDON HOTEL. This hotel was established in 1871 by John Harris and Arthur Aldrich. In 1869 both men entered into an agreement to lease the land from D.L. Palmer and Sarah P. Ferris. Harris was to build the hotel while Aldrich was to "attend to the bathing department of the spring." Their lease was for 25 years.

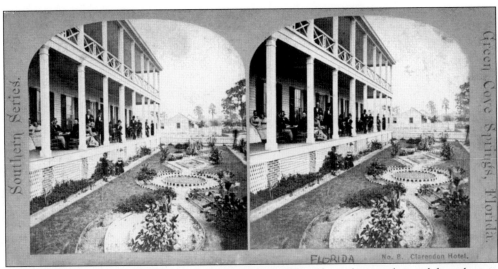

CLARENDON HOTEL FRONT PORCH BY C. SEAVER JR. The Clarendon was located directly west of the spring and could accommodate about 200 guests. The hotel had all the modern conveniences, such as spring-beds, hair-mattresses, electric bells, hot and cold bath water, a billiard saloon, and a bowling alley. In 1871 Aldrich sold his interest to Joseph Applegate. Applegate continued to run the hotel after Harris died in 1883.

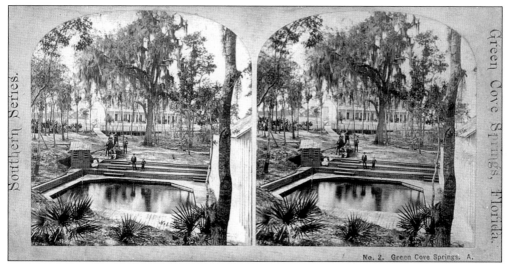

CLARENDON HOTEL AND SPRING BY C. SEAVER JR. In 1871 Harris and Applegate secured permission to run a pipe from the spring to their hotel for the purpose of pumping water. The spring water could be used for cooking, drinking, and for "general use in rooms" except for bathing, in which case the spring owners, Palmer and Ferris, were to be paid 50¢ per bath. The pump house for the hotel is at the upper left of the spring.

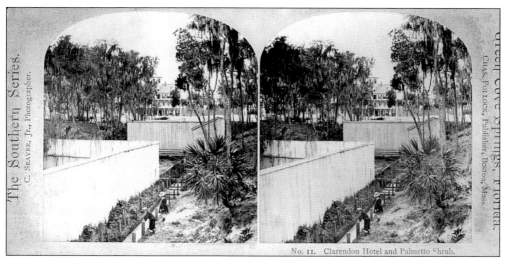

CLARENDON HOTEL AND PALMETTO SCRUB BY C. SEAVER JR. Harris and Applegate created the bathing pools and all the plank sidewalks around the spring. Applegate, a doctor, gave lavish praises about the medical qualities of the spring water. The two bathing pools are pictured here with the Clarendon hotel in the background.

THE CLARENDON HOTEL GARDEN. The hotel's garden was located in front of the main building fronting Magnolia Avenue. Located directly across the street next to the spring was the croquet lawn. The building in the back was one of two cottages operated by the hotel. Today it is the only building remaining from the Clarendon and it is a bed-and-breakfast house. This image is attributed to Isaac Haas. (Courtesy of Matheson Museum.)

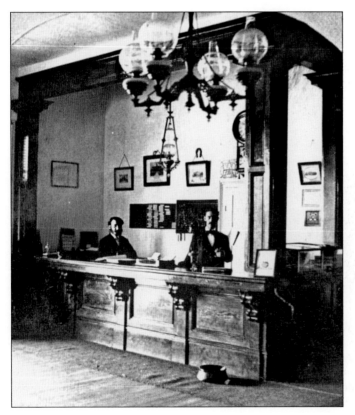

CLARENDON HOTEL'S FRONT DESK. Because of the spring, the Clarendon received top bill for Green Cove Springs. Rates ranged from $3–$3.50 a day or $23 per week. The Clarendon met its demise when it burned to the ground on April 3, 1900. (Courtesy of Florida Photographic Archives.)

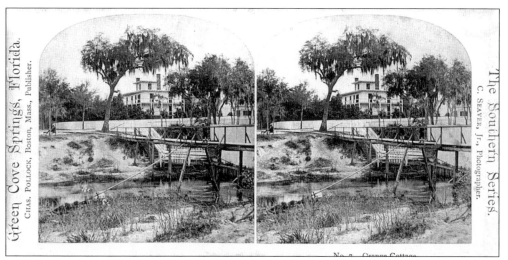

ORANGE COTTAGE BY C. SEAVER JR. Nothing is known of Orange Cottage. Judging from this image, it is assumed that it was located at the corner of Spring Street and St. Johns Avenue. The footbridge over the spring run is in the foreground.

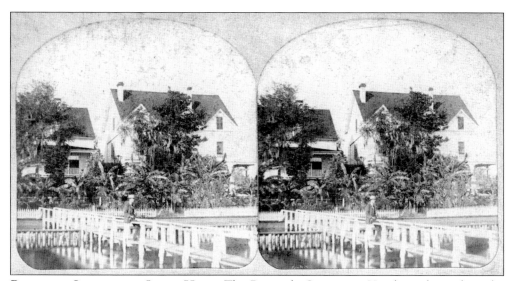

RIVERSIDE COTTAGE BY ISAAC HAAS. The Riverside Cottage or Hotel was located on the banks of the St. Johns River between Palmer and Center Streets. The hotel's grounds were filled with "oleanders, fragrant roses, and numerous other fragrant flowers [that] mingle with sub-tropical plant and vines." (Courtesy of Matheson Museum.)

THE PALMETTO HOUSE. Nothing is known about this hotel. It is possible that it was located south of the spring. This view is attributed to Isaac Haas.

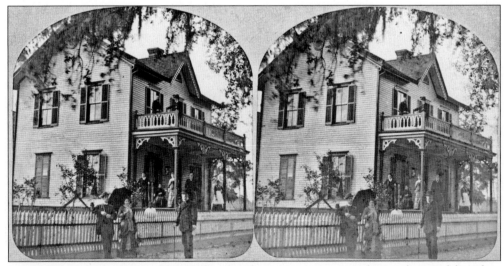

SMITH COTTAGE BY ISAAC HAAS. The Smith Cottage was one of several typical boarding houses that catered to those on a smaller budget. Located directly across from the spring on Spring Street, it provided an ideal location for tourists. This particular image is dated from the winter of 1881. (Courtesy of Matheson Museum.)

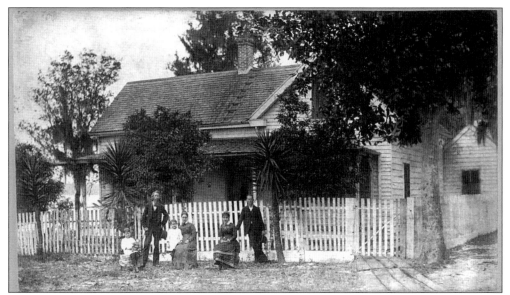

Rufus C. Reed's Cottage by J.S. Mitchell. This small cottage was located on the St. Johns River in the cove at the foot of Spring Street. In 1881 it was described as a "cozy little house . . . with some fine orange trees."

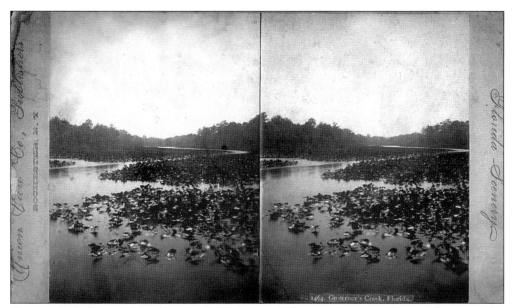

Governor's Creek. After dinner it was suggested that you hire a rowboat and instruct the individual to row to the mouth of the creek and wait there. An after-dinner stroll would then be followed by an excursion upon the creek where one could view endless reflections upon the mirror-like water. All the colors of the sky, trees, moss, vines, and flowing shrubs would be "daguerreotyped in perfection."

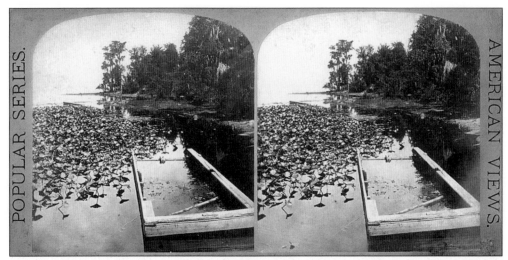

GOVERNOR'S CREEK BY E. AND H.T. ANTHONY. The sunken ferry is all that is left from the original crossing. When the new bridge was built, the ferry was no longer needed. The St. Johns River is in the background.

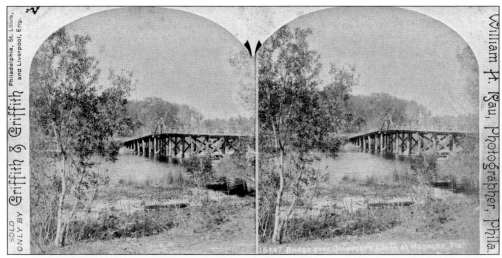

BRIDGE OF GOVERNOR'S CREEK BY WILLIAM H. RAU. This is the new bridge built to connect Green Cove Springs to Magnolia Springs. Rau, who worked as an assistant to other photographers in the 1870s, had decided by the 1890s that he had enough experience to produce his own views. Sometime in the 1890s Rau made a trip to Florida; this image dates from that trip. (Courtesy of Matheson Museum.)

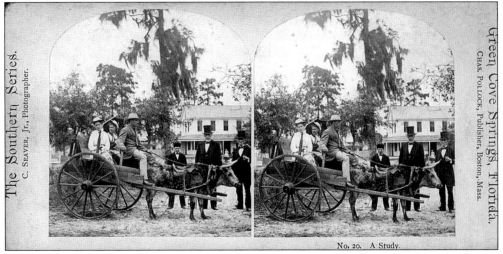

The Southern Series. C. SEAVER, JR., Photographer.

Green Cove Springs, Florida. CHAS. POLLOCK, Publisher, Boston, Mass.

No. 20. A Study.

A STUDY BY C. SEAVER JR. This image by Charles Seaver was taken in the early 1870s and shows the typical spoof on the Florida cracker transportation. Captions such as the "Florida Express" or "Lightning Express" were used to poke fun at the local transportation.

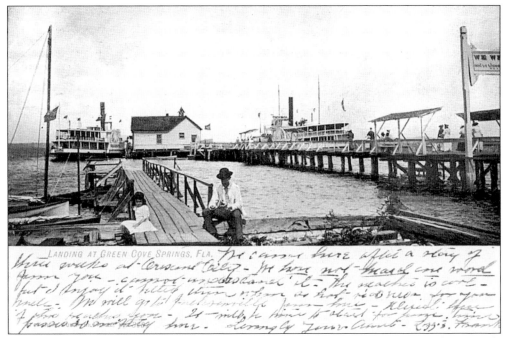

THE LANDING AT GREEN COVE SPRINGS. This postcard dated March 1911 shows that a steady flow of tourists still stopped in Green Cove Springs. The two large steamboats were typical of those that made runs up the St. Johns River from Jacksonville to Enterprise.

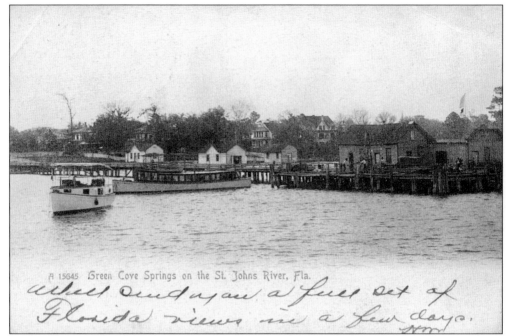

A 15645 Green Cove Springs on the St. Johns River, Fla.

[handwritten text]

GREEN COVE SPRINGS ON THE ST. JOHNS RIVER. This view shows the main wharf at the end of Walnut Street looking in a northwesterly direction. The Riverside Cottage is in the middle background while the cupola from the St. Clair can just be seen above the roof of the main boathouse of the wharf. (Courtesy of Matheson Museum.)

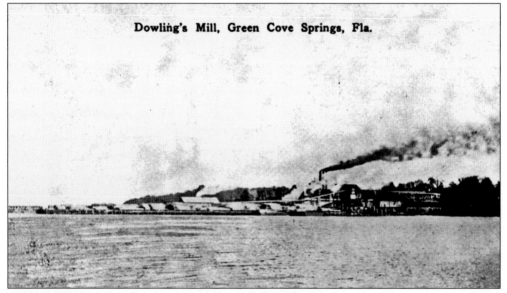

Dowling's Mill, Green Cove Springs, Fla.

DOWLING'S MILL. R.L. Dowling operated a mill along the south bank of Governor's Creek and the St. Johns River. In 1911 Dowling incorporated with the Shands Lumber Company. One of the first sawmills in Green Cove Springs was operated by Henry M. Burrows. Burrows's mill could produce 10,000 feet of material a day. Most of the lumber for the mills was obtained from the lands along Black Creek; logs would be floated down the creek and towed to mills. (Courtesy of Florida Photographic Archives.)

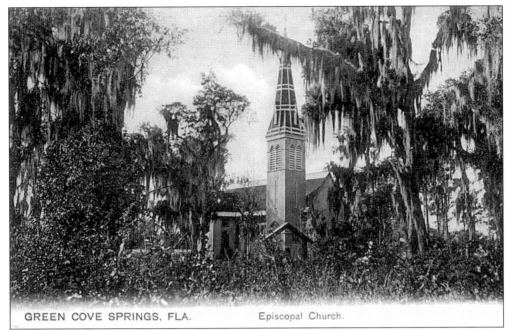

GREEN COVE SPRINGS, FLA. Episcopal Church.

THE EPISCOPAL CHURCH. St. Mary's Episcopal Church was built on the banks of the St. Johns River in 1878 on land donated by Thaddeus Davids. The first service in the church was conducted by the Reverend Aspinwall on March 9, 1879. Services are still held in the building today. This postcard dates from 1907.

THE METHODIST CHURCH.
The Methodist Church in Green Cove Springs was first organized in 1871 when Rev. S.S. More was assigned to the area. Notice that the architecture of this church resembles that of the Methodist Church in Middleburg pictured on page 10. (Courtesy of Florida Photographic Archives.)

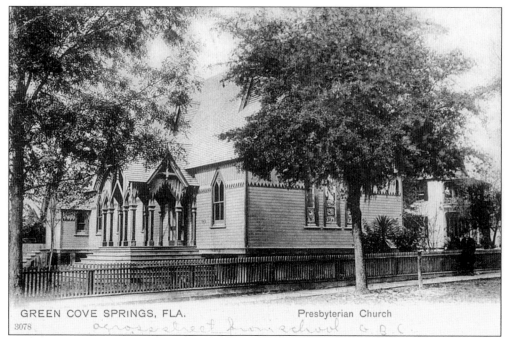

GREEN COVE SPRINGS, FLA. Presbyterian Church

3078 *across street from school G B C*

THE PRESBYTERIAN CHURCH C. 1908. The church was first organized in 1884, meeting at the home of Elizabeth Shepardson. Soon thereafter the members decided to build a sanctuary. The building was designed by architect A.J. Wood of New York with a Gothic style. A large stained glass window depicting Jesus as the good shepherd faces Magnolia Street. This window is located just behind the tree in the middle of the image.

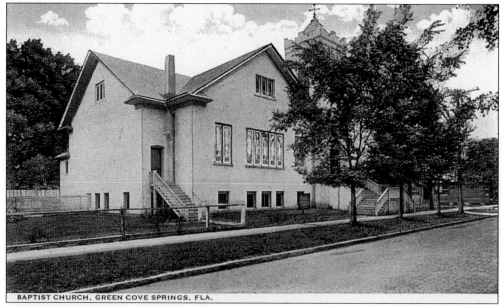

BAPTIST CHURCH, GREEN COVE SPRINGS, FLA.

THE BAPTIST CHURCH. The First Baptist Church was organized in 1889 by Rev. Dr. Henry Talbird. Outgrowing their original building on Gration Street, the church built a larger structure on Walnut Street that was completed on June 11, 1916. The first service in the new structure, pictured here, was delivered by Rev. J.B. Rogers.

74

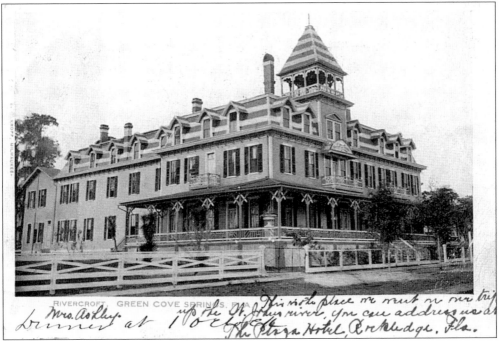

THE RIVERCROFT HOTEL (ST. ELMO HOTEL). The Florida Military Academy acquired the property originally known as the St. Elmo Hotel in 1911. Prior to the Florida Military Academy's acquisition, the hotel went through several name changes as riverboat traveling was declining. Called the Morganza in 1902, the hotel struggled and sometime between 1902 and 1911 it was named the Rivercroft. In 1889 the daily room rate was $1.50–$2. This postcard dates from 1906.

THE TYLER HOUSE. The Tyler House was located on the corner of Walnut Street and Pine Avenue along the line of the streetcar a few blocks west of the spring. A 1905 brochure asked the visitor to look for the porter with a "Tyler House" badge on his hat and to "go with him to this house and you will not regret it." By 1917 the hotel had changed its name to the Seminole Hotel. This postcard dates from 1911.

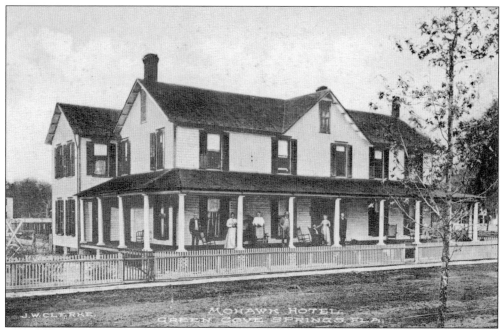

THE MOHAWK HOTEL. Originally built as a private residence, the Mohawk Hotel was converted into a hotel sometime between 1909 and 1917. Comprised of 35 rooms and 8 bathrooms, boarders were charged $5 a week. Renovated during World War II, it became a place for traveling soldiers to rest. In the summer of 1963 it was torn down. It was located at the corner of Palmer Street and Palmetto Avenue. (Courtesy of Matheson Museum.)

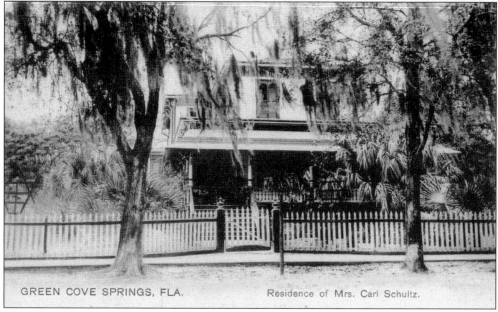

THE RESIDENCE OF MRS. CARL SCHULTZ. This was the winter residence of Mrs. Carl H. Schultz of New York City. In the winter, the Schultz family would spend time touring Florida. Occasionally they would hunt alligators on Black Creek. Their house was said to be a place that all tourists should see. (Courtesy of Matheson Museum.)

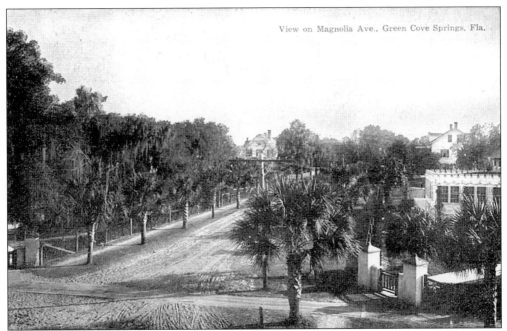

A VIEW ON MAGNOLIA AVENUE. After the Clarendon burned in 1900, the lot remained vacant until 1907 when the Qui-Si-Sana was built. In this postcard dated December 24, 1915, the hotel is on the right and the spring on the left. In the background on the right is one of the original Clarendon cottages.

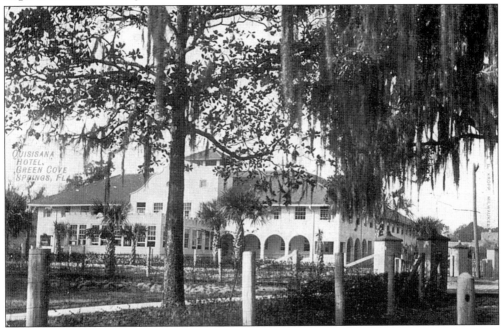

QUI-SI-SANA HOTEL. Located on the same site as the Clarendon, the hotel was built to be fireproof. Built of concrete block by Louis McKee of New Jersey, it brought immediate improvement to the town. Each room had running water from the spring, steam heat, electric lights, and a telephone. In June 2002, the hotel was torn down to make way for a new town hall.

77

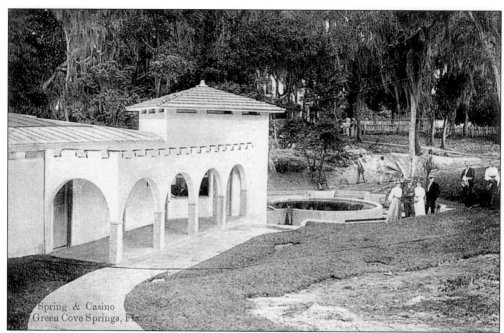

SPRING AND CASINO. The new Spring and Casino Park was built around 1907; long gone was the old wood walkway around the spring. The spring was now enclosed in a circular pool which, with some modification, still stands today. This postcard is dated August 24, 1909.

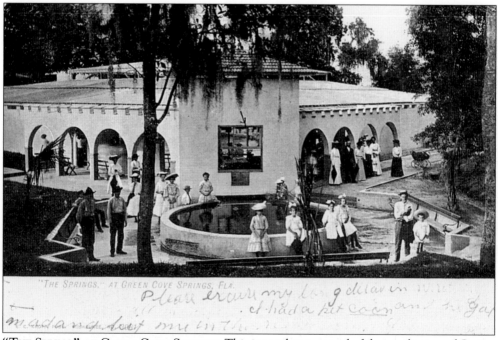

"THE SPRING" AT GREEN COVE SPRINGS. This is another postcard of the newly opened Spring and Casino. The office was located in a small room behind the window pictured in the center. This postcard is dated May 27, 1908.

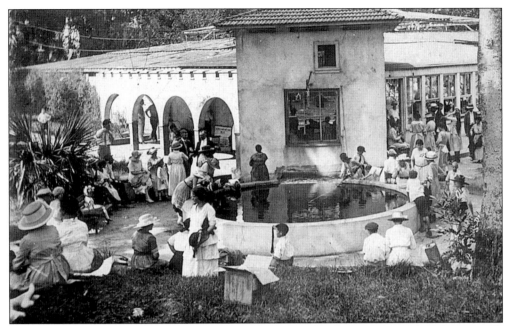

A Gathering at the Spring c. 1917. The spring was still a gathering place for not only tourists but locals as well. Notice that electricity had now been provided and the covered entrance on the right had been expanded into a dance hall.

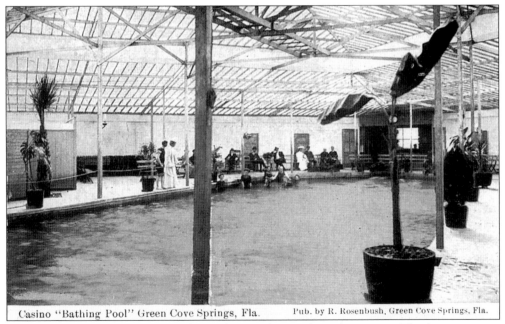

Casino "Bathing Pool" Green Cove Springs, Fla. Pub. by R. Rosenbush, Green Cove Springs, Fla.

Casino "Bathing Pool." Over the pool was a glass roof 100 feet square. The dressing rooms were at the pools and were arranged to face the midday sun.

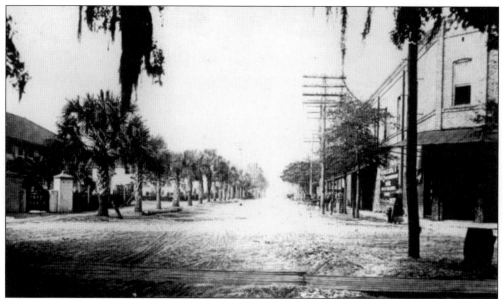

WALNUT STREET LOOKING WEST. In this postcard from the turn of the 20th century, the Qui-Si-Sana is pictured on the left. The string of buildings on the right was a general store, a jeweler, and a bank by 1909. This block was built in 1881 and named the "Crocker Block" by J.C. Crocker, who invested $6,000. By 1919 Walnut Street had been paved with bricks and the block was known as the "Wilson Block." (Courtesy of Florida Photographic Archives.)

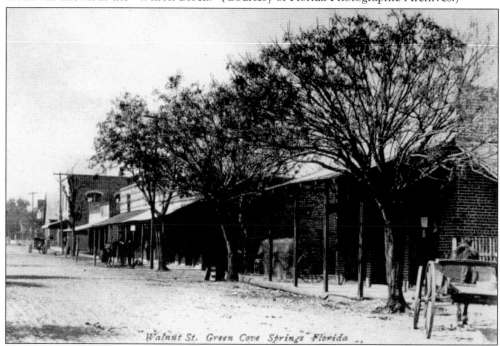

WALNUT STREET. Because the wharf stood at the end of the road, Walnut Street had easily become the road for commerce. By 1884 the post office, telegraph office, and several general stores lined the road. In 1903 the city created a board of trade to help draw new enterprises to the town. This image predates 1919. (Courtesy of Florida Photographic Archives.)

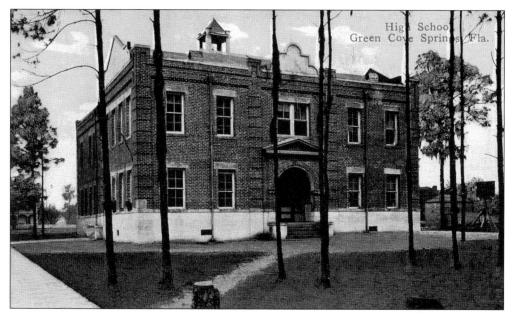

GREEN COVE SPRINGS PUBLIC SCHOOL. Clay County took pride in its education, and in 1905 it levied as much tax for public educational purposes as any other county except for Brevard County. The school year ranged from five to eight months. The high school is pictured after it had been newly expanded and renovated. The school was K-12 and enrolled about 200 pupils. It was located at the intersection of Palmer Street and Pine Avenue. (Courtesy of Clay County Archives.)

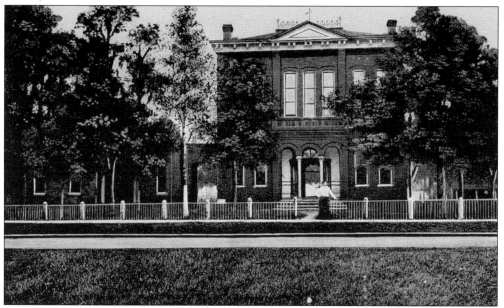

CLAY COUNTY COURTHOUSE. When the county seat moved to Green Cove Springs in 1871, a new county courthouse and jail were needed. The courthouse was a two-story frame structure. Because of the growth of the county, a larger, more elegant courthouse was needed. In 1890 a new brick building was constructed with a new, larger county jail adjacent. (Courtesy of Clay County Archives.)

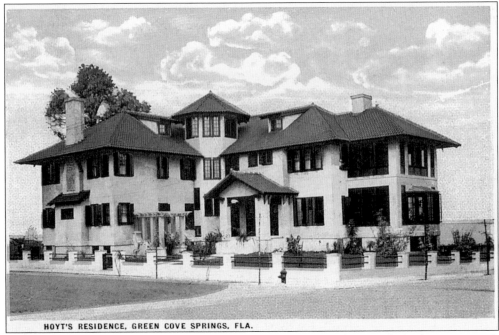

HOYT'S RESIDENCE, GREEN COVE SPRINGS, FLA.

HOYTS' RESIDENCE. The Honorable W.M. Hoyt of Chicago had originally built a nice wood-frame house in town. Outgrowing their modest residence, the family expanded and built a larger, more elegant house made of block with a tile roof. The Hoyts started spending their winters in Green Cove around 1877.

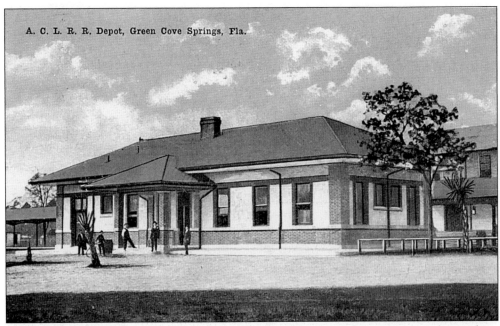

A. C. L. R. R. Depot, Green Cove Springs, Fla.

A.C.L.R.R. DEPOT. The Atlantic Coast Line Railroad depot was located just on the outskirts of town at the intersection of Ferris Street and Idlewild Avenue. The horse-drawn trolley ran to the station so it could transport visitors to their hotels. It was also known as Union Station.

Six

ISAAC HAAS

The son of John and Rebecca Haas, Isaac was born on August 8, 1846, in the town of Garey's Ferry, now Middleburg. He died December 5, 1902, and is buried in the old portion of the Hickory Grove Cemetery in Green Cove Springs. Isaac appears to have been born into an educated family as his father John represented his father-in-law Isaac Varn Sr. in legal matters concerning Varn's preemption claim of 1838, which also included numerous petitions to Congress. John Haas was also a county commissioner for the year of 1865. Much of Isaac Haas's early life is unknown and none of the Haas family appear in the 1870 census. However, the earliest tax return from Clay County shows Isaac on lot 2 block 3 in Green Cove Springs. His property with improvements was valued at $510, for which he paid county taxes of $6.98. Later Haas moved his studio closer to the tourist activity by the spring. His studio was located on lot 5 block 7. Haas was the most prolific and noted photographer from Clay County. His stereoscopic views are mostly of Green Cove Springs and Magnolia Springs. Occasionally a view from Hibernia and Black Creek can be found, but for the most part it appears that he concentrated his trade on the many tourists that visited the area. One travel brochure of the time concluded that he did "excellent work at a fair price" and "at their office is the only curio and souvenir collection in town." His views are marked with two different stamps. The older is the ornate head and shoulders of a lady seated in a chair, while the latter is a smaller and simpler square stamp with a fancy border surrounding his name. Both versions are always stamped in red ink.

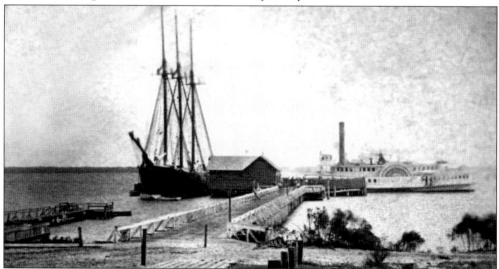

A STEAMER AND A THREE-MAST SHIP AT DOCK. The larger sailing ships were necessary to carry lumber to the North as many of the steamboats were to small to carry a profitable quantity of lumber. (Courtesy of Florida Photographic Archives.)

A Group of Tourists at an Unknown Location in Green Cove Springs. Tourists could easily find transportation at the hotels and docks. A cart could be obtained for as little as a quarter. Although most stores and hotels were located within walking distance of one another, tourists sometimes ventured into the wilderness or visited land that was for sale just outside of town.

Unknown Tourists at Spring Park. Spring Park was the central draw for the visitor. Many walked the small paths throughout the park. Furniture made of vines was commonplace so as to draw the visitor to the natural beauty surrounding them. The man sitting on the ground appears to be Thaddeus Davids, mayor of Green Cove Springs.

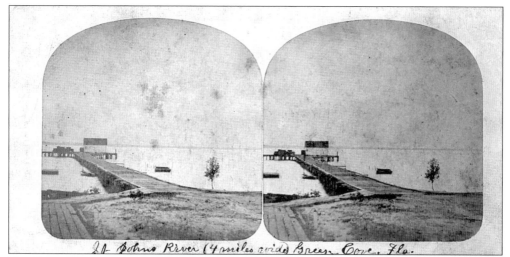

2d Johns River (4 miles wide) Green Cove. Fla.

THE LANDING AT GREEN COVE SPRINGS. This very early view from the early 1870s shows the steamboat landing located at the foot of Walnut Street. The town of Green Cove Springs could boast of nice plank sidewalks as shown.

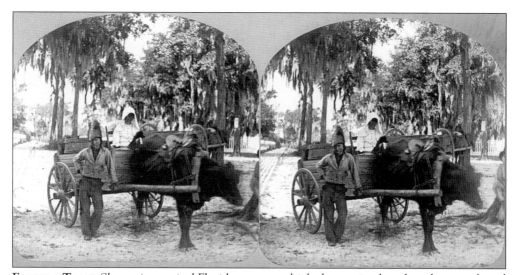

FLORIDA TEAM. Shown is a typical Florida ox-cart, which the tourists loved to photograph and poke fun at by calling them the "Florida Express." Notice the photographer's horse-drawn cart behind the ox-cart and the boy at the far right leaning against the tree.

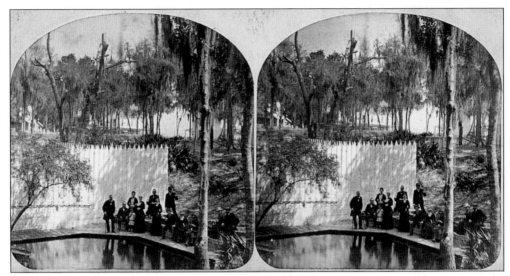

THE SPRING. The spring at Green Cove Springs offered one of the most scenic spots to be photographed. Behind the tall board fence was one of the swimming areas. Several buildings along Walnut Street can be seen in the background.

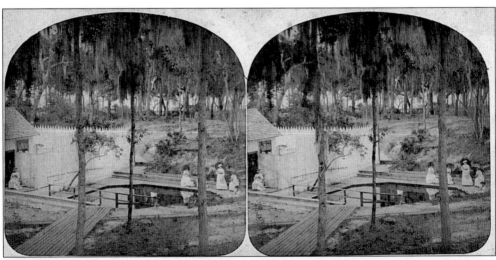

THE SPRING. In this early view the entrance to the first swimming area can be seen at the far right. The waters from the pool were said to be very healthy and were advertised as such. Since the temperature of the water remained at 78 degrees, one could go swimming at all times of the year. The cost for swimming was 50¢.

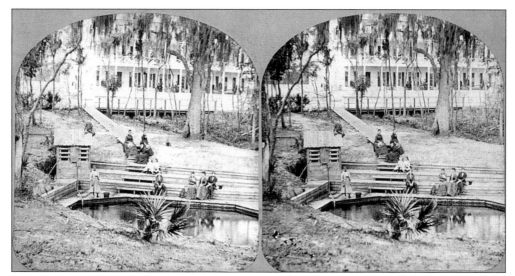

THE SPRING. When the hotels were built around the spring, many used the spring as their source for water. Here a pump-house can be seen with the Clarendon Hotel in the background. The Clarendon was the only hotel that could directly pump water from the spring, but their lease required that the spring water still be made available to town residents at no charge.

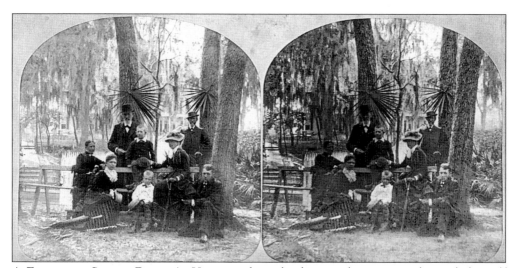

A FAMILY AT SPRING PARK. As Haas was the only photographer in town, he made himself available for all occasions. Notice the palmetto fronds nailed to the trees behind the men standing. The Clarendon hotel can be seen in the background.

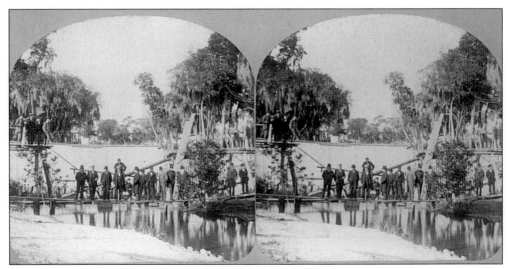

CONSTRUCTION OF A FOOTBRIDGE OVER SPRING RUN. St. Johns Avenue, which runs parallel to the St. Johns River, stopped at the run of the spring. The bridge offered passage, by foot, across the run. Traffic by cart had to turn down Walnut Street, go along Magnolia Avenue, and turn at Spring Street so as to continue along St. Johns Avenue.

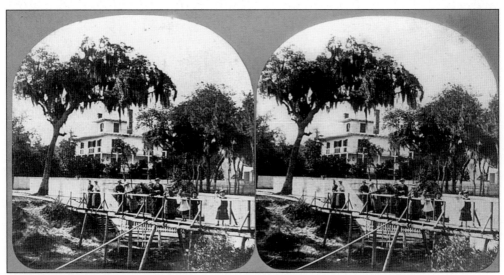

ORANGE COTTAGE. In this view, the completed footbridge is shown. At the corner of Spring Street and St. Johns Avenue was a boarding house called Orange Cottage.

WALNUT STREET IN GREEN COVE SPRINGS, 1882. The town's plank sidewalks and wide streets are clearly visible in this dated image. Walnut Street became the main street for business in town because it led to the town's general landing. Located on this street were a barbershop, a cobbler, several general stores, two churches, a bakery, a photographer's shop, and several hotels and boarding houses.

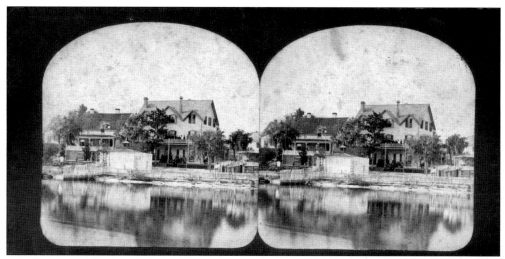

RIVERSIDE COTTAGE. The interior of the hotel was filled with fine furniture made from mahogany, rosewood, black walnut, cherry, and curly pine. The hotel was open all year and the proprietor, Jasper F. Greer, and his family made it their permanent residence. (Courtesy of Matheson Museum.)

Spanish Moss at Green Cove Springs. Moss would be gathered in the winter and then cleaned to get rid of redbugs. Once cleaned it would be spread out in drying yards where it would dry until processed.

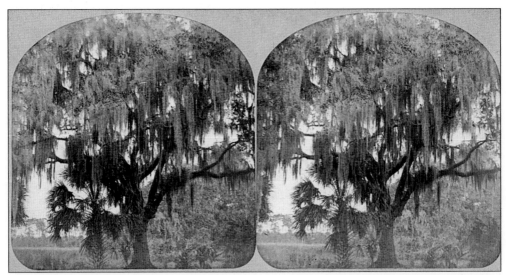

Live Oak and Moss. Florida's semi-tropical climate offered tourists the ability to see a wide variety of plants not found in the North. The moss that covered the trees drew many to view it as a curiosity. Floridians found a variety of uses for the moss, chiefly as stuffing for mattresses.

CABBAGE PALMETTO. The scenery along the St. Johns River offered the Northern tourist something new and strange at every step. One description of this was written in 1884: "The only things which are uniform and monotonous are the long grey moss, which drape the gnarled arms of the oaks and cypress, giving to the woodlands a wild and weird appearance."

PYRAMID. The flora in the winter and early spring was abundant and varied for the tourists. Each plant having its own time to bloom, the visitor was greeted with orange blossoms, hibiscus, magnolia, oleander, and many others. A garden in the winter was much of a surprise to the Northern tourist.

BAYONET BLOSSOM. The Spanish bayonet is a type of yucca plant that has sharp points at the end of the leaves. The plant can grow as tall as 20 feet and it blooms in the spring. Many of these plants were used in yards to help promote tropical scenery. The Magnolia Springs Hotel planted dozens of these at the railroad station and along the tram tracks leading to the hotel.

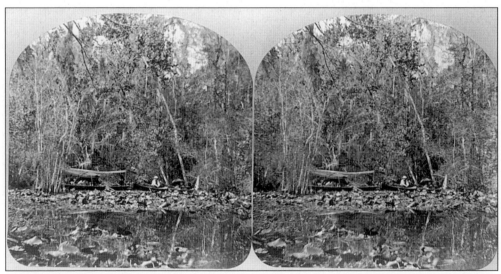

A SCENE ON GOVERNOR'S CREEK. Governor's Creek offered tourists scenic views of Florida's creeks without having to take a day trip up Black Creek or a longer trip to the Ocklawaha further up the St. Johns River. Because of its location and its natural wonderment, it quickly became a "must see" while staying in Green Cove Springs.

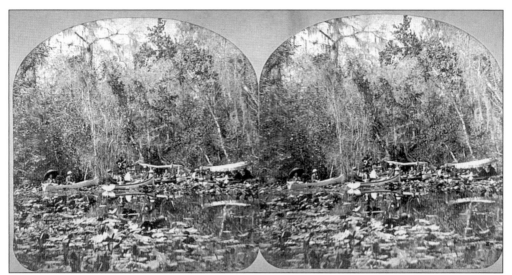

VIEWS ON GOVERNOR'S CREEK. Governor's Creek was a small creek that separated Green Cove Springs and Magnolia Springs. Once away from the mouth of the creek it narrows rapidly. Patrons of the Magnolia Springs Hotel could rent boats and easily explore the creek, located only a few hundred yards away. One travel brochure wrote that "nothing is seen save Nature in her loveliest dress; nothing is heard save the ripple of the stream by the boat side, the song of birds. . . . when the evening comes, the moon invests with a new splendor the beauties of the day. Let the artist faintly sketch the scene."

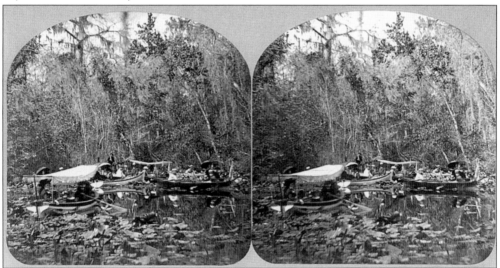

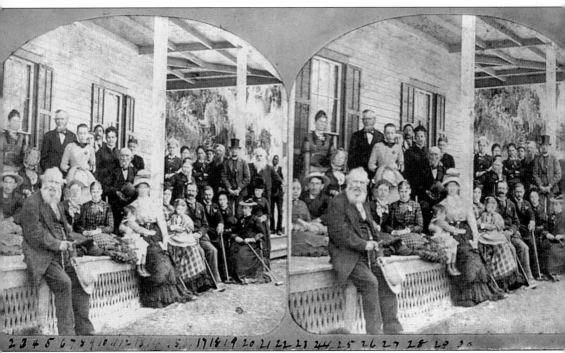

A GROUP OF TOURISTS ASSEMBLED FOR A PICTURE. Each guest was identified on the back of the card: 1. Katie E. Brown; 2. Frank L. Crosby; 3. H.L. Crosby; 4. Mrs. Isaac T. Smith; 5. Thaddeus Davids, Mayor of Green Cove Springs; 6. J. Crosby; 7. Louise Brown; 8. Sallie S. Duncan; 9. J. Collins Duncan; 10. Mrs. J.W. Duncan; 11. Charles E. Crosby; 12. Rebecca F. Cove; 13. Austin Cove; 14. Ellen N. Lee; 15. Mrs. Charles H. Hildreth; 16. Susan Bond; 17. W.J. Brown; 18. O. Brown; 19. Mrs. J. Hazzard; 20. unidentified; 21. unidentified; 22. unidentified; 23. Capt. Charles Hazzard; 24. unidentified; 25. C.M. Brown; 26. Thomas A. Brown; 27. Mrs. Titort; 28. Mrs. Hazzard; 29. unidentified; 30. unidentified.

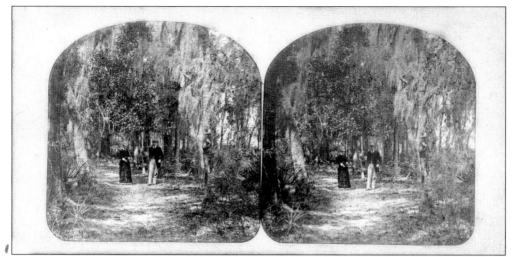

A VIEW OF ST. DAVID'S PATH. This path started just north of the Riverside Cottage at Center Street and terminated at Governor's Creek within site of the Magnolia Hotel. It was sometimes called "Lover's Walk" originating from a legend that "bachelors and maidens who dare to brave its precincts in company, are sure to come out lovers." It was lined with magnolias, live oaks, and azaleas. Intertwined in the branches were vines of grapes, morning glory, and jasmine. (Courtesy of Matheson Museum.)

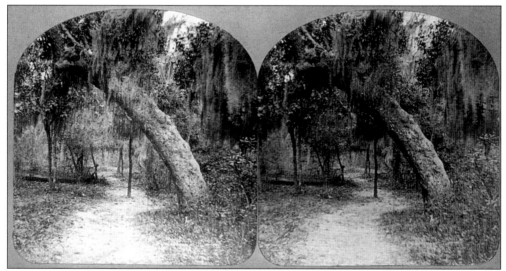

A VIEW OF ST. DAVID'S PATH. This path ran along the banks of the St. Johns River for nearly two miles. It was advertised that the astonished traveler could view "vista after vista of surpassing loveliness open before the raptured eye." When weary, the visitor could rest on a bench in the midst of freshness and beauty and listen to the song of birds, inhale the odor of the orange, and be refreshed by the balmy breeze.

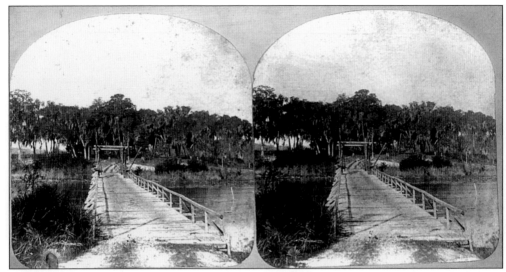

A BRIDGE ON GOVERNOR'S CREEK. This bridge provided an easy path over the creek. Prior to its construction, a small ferry was in operation. On September 16, 1872, it was reported that the bridge was in a "dilapidated condition . . . which renders it unsafe for horses to pass." A new bridge was to be constructed directly south of the current one.

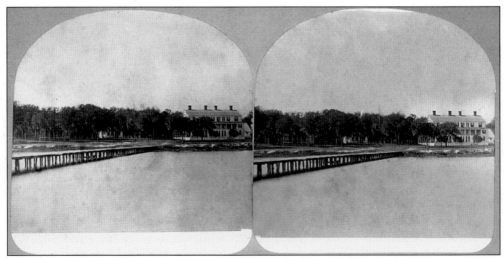

MAGNOLIA FROM THE WHARF, C. 1876. This image shows the original hotel at Magnolia. During the Civil War, the Union Army made their headquarters nearby. Once the army had established their camp, a few families loyal to the Union made their way to the encampment only to be left behind when the post was abandoned after a few months of occupation.

IN THE COUNTRY: BUTLER'S PLANTATION. The two men at right provide the music while the two on the left dance up a storm. The corncrib in the back is of typical construction with a cypress shingle roof. (Courtesy of Matheson Museum.)

BUTLER'S HOME. This is a typical single-pen–style Florida frame house. The house consisted of a single room with a wrap-around porch. The lumber was acquired from a local mill. This style house certainly would not have been built in town but rather out in the country. (Courtesy of Matheson Museum.)

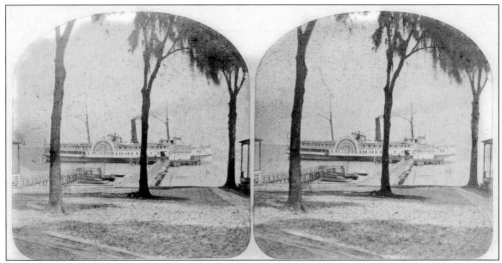

STEAMER *ST. JOHNS*. The *St. Johns* was built in 1878 in Wilmington, Delaware. She was 250 feet in length with a width of 38 feet. Built with an iron hull, she was able to sail for a long time. In 1968 she was scrapped. (Courtesy of Matheson Museum.)

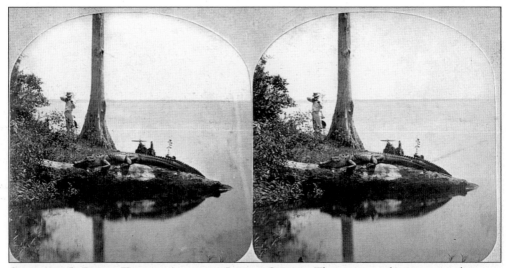

CLARENCE J. DAVIS TAKING AIM AT A LARGE GATOR. The gator in this instance does not appear to be a prop. Many tourists were pictured with gators that had been stuffed. An excursion down Black Creek was advertised as the best place to see alligators.

Seven
FLORIDA MILITARY ACADEMY

The Florida Military Academy at Magnolia was formed around 1907 and was located at the St. Elmo Hotel in Green Cove Springs until 1916. During that year the academy moved into the Magnolia Springs Hotel. The academy enjoyed the luxuries still remaining from the old hotel until it burned on November 11, 1923. After that the cadets and faculty resided in the cottages that still remained from the hotel. The school continued on for several more years until moving to Jacksonville in the early 1930s. Col. George W. Hulvey was superintendent of the school the entire time it was located in Green Cove Springs and Magnolia. The school taught each boy the right habits of thought, study, and play. The student could remain at school only so long as he conducted himself as a gentleman. To be admitted, the young man must be of good character and have passed the second grade. Classes for a typical year consisted of English, mathematics, history, and one foreign language: Latin, French, or Spanish. In addition to the four classes spelling and penmanship were also taught. The day the school burned, the cadets were in Green Cove Springs. As they returned, Colonel Hulvey formed the cadets up and counted to make sure none were missing. The older cadets were allowed to go into the hotel and remove all furniture and other items until it was no longer safe for them to do so. The cadets would throw their belongings on their bed, grab the blanket by the four corners, and throw it over their shoulders. The smoke from the fire could be seen as far away as Jacksonville.

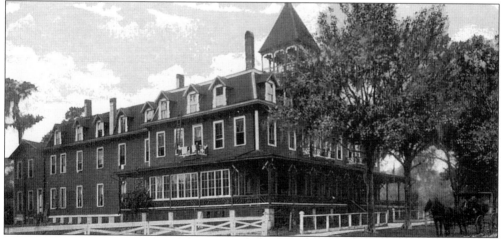

FLORIDA MILITARY ACADEMY. The academy is shown when it was at the old St. Elmo Hotel. The horse-drawn cart is on St. Johns Avenue, which runs parallel to the river.

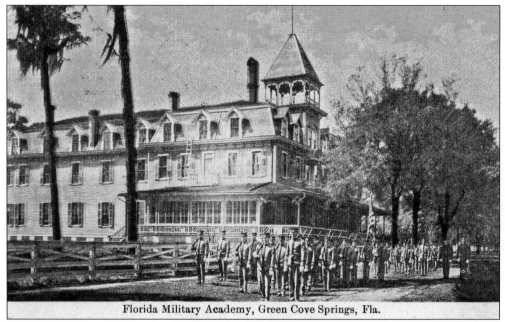

Florida Military Academy, Green Cove Springs, Fla.

CADETS IN FORMATION AT ST. ELMO HOTEL. The number of cadets was typically between 60 and 75 during the later years of the school. Their dress uniforms were modeled on an English officer's style made of Charlottesville woolen grey cloth, while the service uniform was made from Winterfield green cloth. Once the uniforms were issued, no cadet was allowed any civilian clothes. (Courtesy of Matheson Museum.)

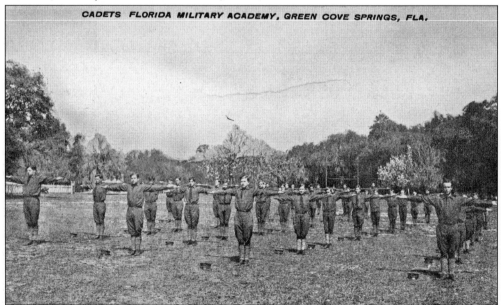

CADETS AT FLORIDA MILITARY ACADEMY. All boys were required to participate in athletics. The school departed from the custom of having the "physically robust" boys playing the games while the "weaker fellows" practiced their "lung development" in "yelling squads." Each cadet would receive a carefully planned course in physical training that would help him in every way to develop into a "manly fellow." (Courtesy of Matheson Museum.)

100

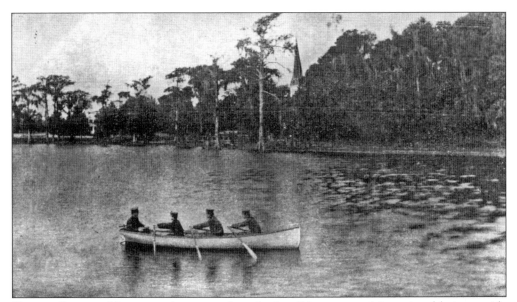

CADETS ROWING NEAR THE ACADEMY. In order for all boys to participate in athletics, a wide variety of sporting clubs were offered. Some of the clubs to choose from were football, basketball, baseball, tennis, swimming, rowing, track and field, and volleyball. (Courtesy of Clay County Archives.)

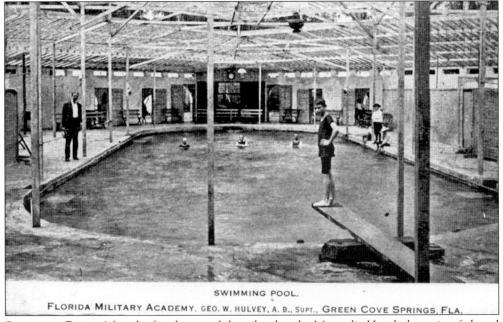

SWIMMING POOL.
FLORIDA MILITARY ACADEMY. GEO. W. HULVEY, A. B., SUPT., GREEN COVE SPRINGS, FLA.

SWIMMING POOL. After the fire destroyed the school at the Magnolia Hotel, the spring-fed pool at the Qui-Si-Sana was used. A member of the faculty was always present during swimming hours. (Courtesy of Florida Photographic Archives.)

Florida Military Academy

Green Cove Springs, Florida

This school is exceptionally well fitted to prepare boys for Universities and the Government Academies. It believes in thorough scholastic training with a solid physical foundation. There is one teacher to every 10 boys. The school's location is ideal, 30 miles south of Jacksonville, in the "land of flowers and sunshine," where the average monthly temperature during the past ten years has not been above 77 degrees nor lower than 53. There is excellent fishing, boating, hunting and outdoor sports, including golf, all seasons. Elegant swimming pool, open air gymnasium. The school buildings are large, elegantly equipped, and the appointments are the best. Rates only $385.

Illustrated catalogue telling the full story of this school and describing its beautiful surroundings, will be sent upon request. Address

GEORGE W. HULVEY, Supt., Box E

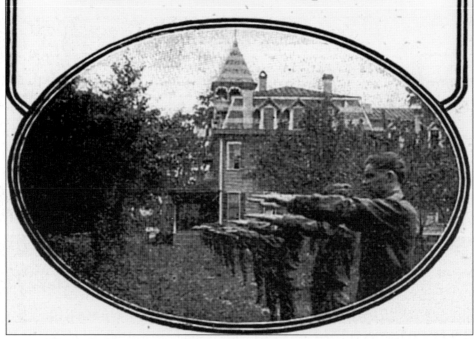

AD FROM MUNSEY'S MAGAZINE, C. 1909. The cadets here are formed on the grounds of the St. Elmo Hotel.

Eight

KEYSTONE HEIGHTS

Keystone Heights first started out as a small village on Lake Geneva. In 1903 a railroad station was opened on the Georgia Southern Railroad, and by 1908 a small hotel with a post office and store was built. In 1919 John J. Lawrence and his brother J.H. formed the Lawrence Development Company. The company plotted out the roads and lots of the new town called Keystone Heights in 1922. By 1924 the post office was moved to the town, and on January 1 the Keystone Inn was opened. Eight trains traveled daily though the station at Keystone on the Georgia Southern Railway, bringing new visitors with them. The company, in hopes of attracting new residences, created a series of stereoscopic views and brochures and sent them to the state of Pennsylvania. In April 1925, the town was incorporated, and by 1926 Keystone Heights could boast of a church, hotel, fire department, public beach, school, a nine-hole golf course, and numerous cottages scattered around the many lakes. By 1930 the town consisted of 320 individuals. When Camp Blanding was built, Keystone became a summer resort to visit. With its many sand-bottom lakes and private cabins to rent, it became popular both with local residents of Clay County and visitors from outside the state.

THE BUSINESS DISTRICT. Today many businesses are still located in this area of the town that was created in 1925. The main road through the district is Lawrence Boulevard. (Courtesy of Florida Photographic Archives.)

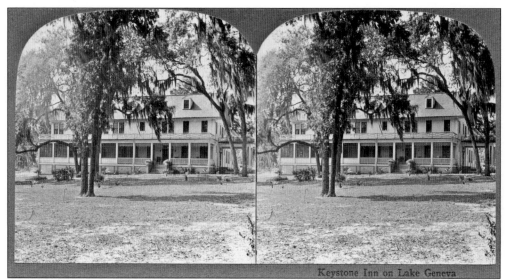

Keystone Inn on Lake Geneva

THE KEYSTONE INN. The inn, built in 1923, served as the focal point for the tourists. Conveniently located at Lake Geneva, the resort offered a delightful place for Northerners to spend the winter. It offered fishing, boating, and a putting green. Residents from Gainesville and Jacksonville popularized the resort as an ideal weekend destination. (Courtesy of Matheson Museum.)

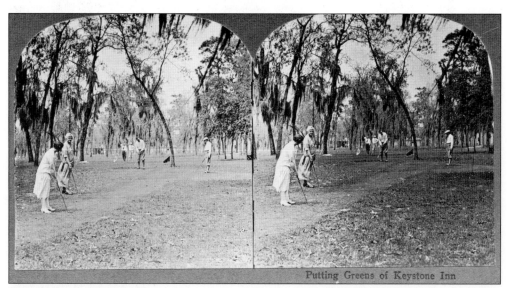

Putting Greens of Keystone Inn

THE PUTTING GREEN. The putting green of the Keystone Inn offered its guests an outdoor activity that all could participate in. A few years after opening, the inn added a nine-hole golf course. (Courtesy of Matheson Museum.)

104

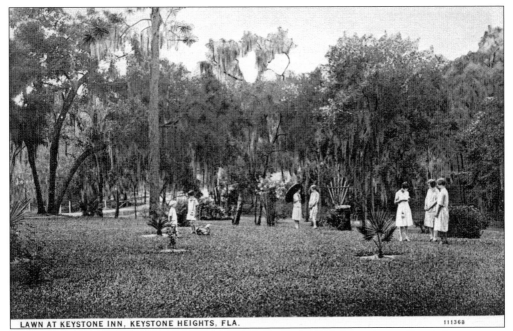

THE LAWN AT THE KEYSTONE INN. The well-kept lawn and gardens offered the guests a relaxing way to enjoy the natural beauty of Keystone Heights. Guests could stroll to Lake Geneva or walk to the nearby business district. Long neglected, the inn was torn down in July 1999. (Courtesy of Matheson Museum.)

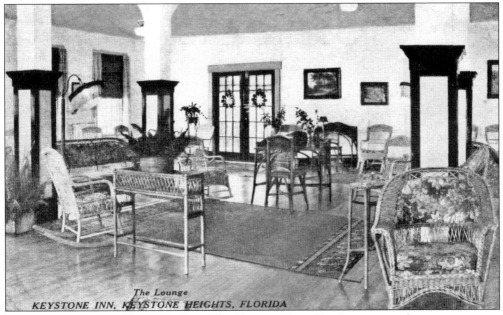

THE LOUNGE AT THE KEYSTONE INN. The Keystone Inn offered its guests a fine summer resort atmosphere by the 1940s. The bedrooms featured metal furniture, making them "vermin-proof." Many town meetings and banquets were held at the inn because of its accommodations. Even the University of Florida football team stayed there before its homecoming games. (Courtesy of Matheson Museum.)

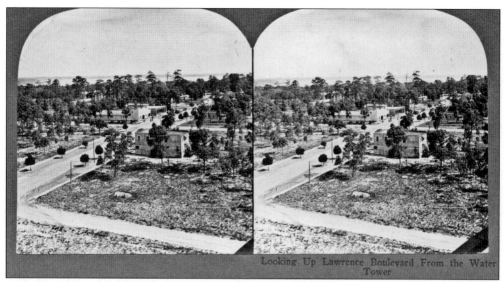

Looking Up Lawrence Boulevard From the Water
Tower

LOOKING UP LAWRENCE BOULEVARD FROM THE WATER TOWER. This view shows most of the business district. The buildings within the district had to be of stucco or masonry construction and approved by the city council. The boulevard was 80 feet wide and lined on either side with camphor trees. As of June 1926, the business district encompassed eight blocks with several more planned. Lake Geneva can be seen in the distance. (Courtesy of Matheson Museum.)

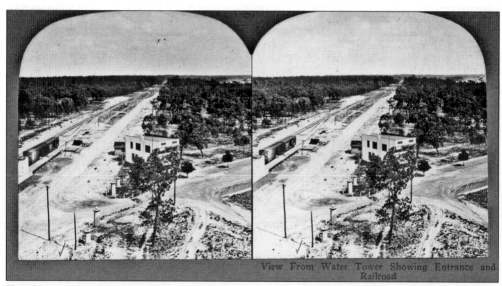

View From Water Tower Showing Entrance and
Railroad

THE VIEW FROM THE WATER TOWER SHOWING THE ENTRANCE TO KEYSTONE HEIGHTS AND THE RAILROAD. To the left of center are located four stucco pillars that are lighted at all times to welcome visitors to the town. In the center is the grocery store, which once housed the post office until it moved two blocks away. The Southern Railroad unloading platform is shown on the left. (Courtesy of Matheson Museum.)

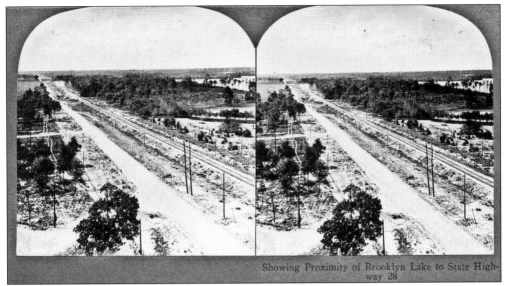

Showing Proximity of Brooklyn Lake to State Highway 28

THE SOUTHERN RAILROAD AND STATE HIGHWAY 28. The railroad helped to open the town but it was the state highway that enabled local Floridians to make frequent trips to the town. The highway ran from Lake City to Palatka. When the road was complete it was advertised to be the main artery for those traveling from the North to Central Florida. The highway is still used today as Highway 100. (Courtesy of Matheson Museum.)

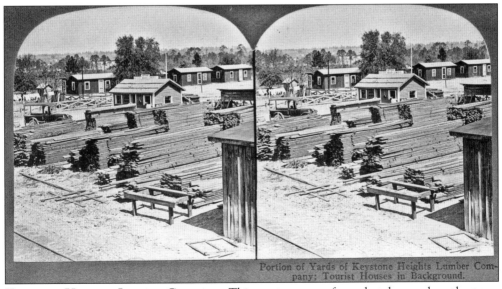

Portion of Yards of Keystone Heights Lumber Company; Tourist Houses in Background.

KEYSTONE HEIGHTS LUMBER COMPANY. This company was formed early on when the town was being planned. It primarily supplied lumber for the various buildings being constructed. The lumber company advertised that they could supply lumber at 20–40 percent less than what the same materials would cost in the North. Southern pine and cypress were the principle woods used. (Courtesy of Matheson Museum.)

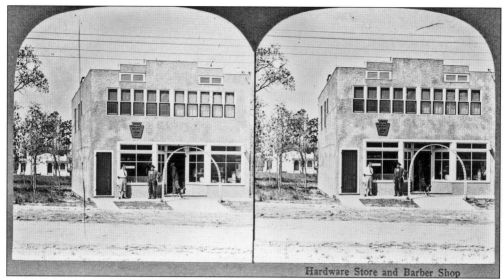

A Hardware Store and Barber Shop in Keystone Heights. The plaque on the wall is inscribed "Keystone Heights Board of Trade." (Courtesy of Matheson Museum.)

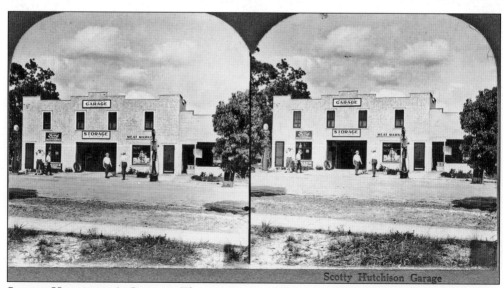

Scotty Hutchison's Garage. The garage was a full-service filling station that offered repair work. It also served as a meat market, as indicated by the sign on the lower left of the building, and as a Ford sales and service dealer. (Courtesy of Matheson Museum.)

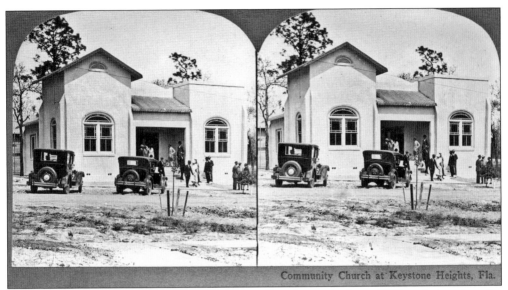

Community Church at Keystone Heights, Fla.

THE COMMUNITY CHURCH. The Community Church was built in 1925 and served as the town's only church for the next 25 years. Under the leadership of Rev. Edgar Mowry, the well-attended services were a "source of inspiration to the community." By combining all denominations into one church, the congregation was to be a "natural expression of the spirit of cooperation and warm friendliness of the community." (Courtesy of Matheson Museum.)

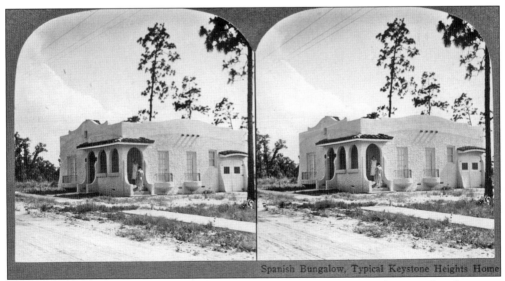

Spanish Bungalow, Typical Keystone Heights Home

A TYPICAL KEYSTONE HEIGHTS HOUSE. The Spanish bungalow was the typical architecture of the new homes. The style was to help blend into the sunny skies of the land of flowers. In many cases the tiles for the roofs were brought in from Spain. This house was built by William Parks of Meadville, Pennsylvania. (Courtesy of Matheson Museum.)

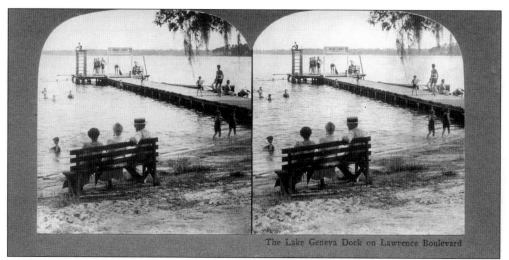

The Lake Geneva Dock on Lawrence Boulevard

SWIMMING AT LAKE GENEVA. Lake Geneva offered beautiful sand-bottom, spring-fed lakes for recreation for the tourists staying at the Keystone Inn. The pier offered a platform to jump off into the deep cool waters of the lake. The lake was advertised as being seldom deserted, and swimming was possible every day of the year. Today the lake still draws many locals during the summer. (Courtesy of Matheson Museum.)

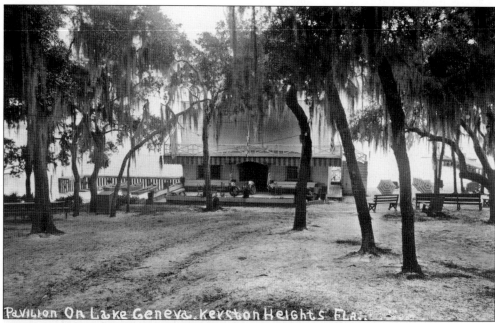

Pavilion On Lake Geneva. Keyston Heights Fla.

THE PAVILION ON LAKE GENEVA. The pavilion on Lake Geneva provided picnic facilities for those who wished to enjoy the lake. It was the center of the public beach on Lake Geneva and was located relatively close to the Keystone Inn. The sender of this card wrote on the back that they enjoyed their Sunday drive to Keystone Heights and "the lake was so blue." (Courtesy of Matheson Museum.)

Nine

PENNEY FARMS

Penney Farms, first known as Long Branch, was incorporated in the spring of 1927. J.C. Penney had been looking for an opportunity to help struggling farmers and retired clergy and to honor his parents; then, in 1924, the land of the Florida Farms and Industries Co. was being auctioned off to the public. Penney met with his executives in New York. Out of these meetings and with the help of Ralph W. Gwinn, the J.C. Penney–Gwinn Corporation was formed. On February 24, 1925, Penney's bid of $400,000 was accepted by Clay County and he was the proud owner of 120,000 acres. Penney then began the process of creating a self-sufficient farming community with an emphasis on the old Bordenville Dairy that had been established in 1921. A combination of the Great Depression and difficulties transporting the crops to market killed the community. In 1932 Penney was bankrupt and Paul E. Reinhold purchased the property. Reinhold expanded the cattle industries that Penney had started, and the dairy products were under the label of Foremost. Before Penney's financial problems, he had started the Memorial Home Community in 1926 with 60 acres from the original 120,000. This community was created by Penney as a memorial to his father and mother and was to be used by retired ministers and their families, along with other religious workers. On June 3, 1932, Penney gave this community a quitclaim deed to the property. After 75 years the Memorial Home is still successful.

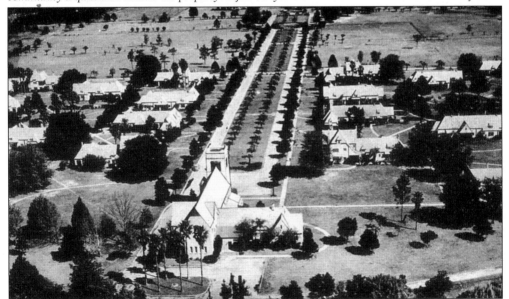

AN AERIAL VIEW OF PENNEY FARMS. The Penney Memorial Church, located at the bottom, greeted visitors as they drove to the end of Poling Boulevard. The open area north of the houses became the town's nine-hole golf course.

111

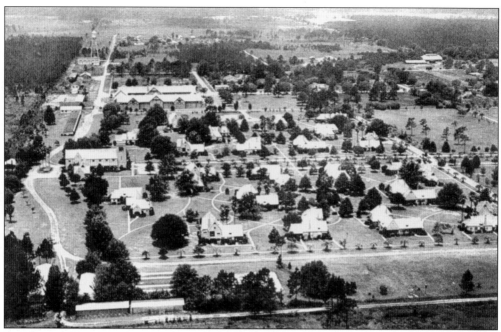

AN AERIAL VIEW OF PENNEY FARMS LOOKING WEST. This view shows much of the entire town. The Christian Herald Quadrangle can be seen in the upper left. Poling Boulevard runs through the center to the church. (Courtesy of Clay County Archives.)

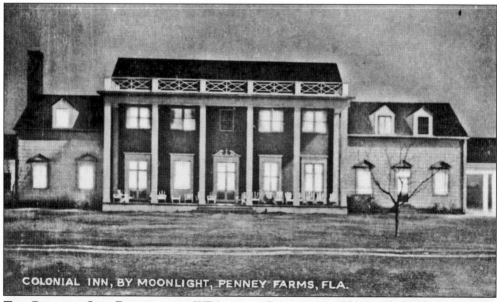

COLONIAL INN, BY MOONLIGHT, PENNEY FARMS, FLA.

THE COLONIAL INN, BUILT BY THE WPA IN THE LATE 1930S. The Bonds family first ran the inn with all the social graces of the day. Later, when Mary Paxton took over the management, the inn became more relaxed. Red maple tables were placed downstairs as writing desks or for playing board games while the rooms for rent occupied the upper floor. White Adirondack chairs lined the front porch. (Courtesy of Clay County Archives.)

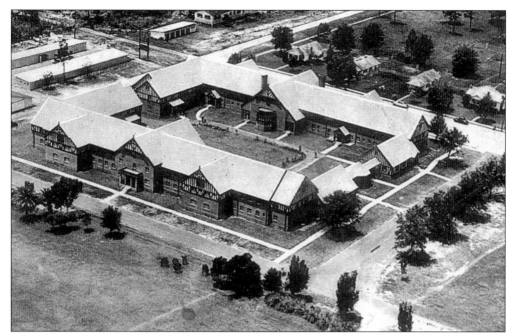

AN AERIAL VIEW OF THE CHRISTIAN HERALD QUADRANGLE. Even today this building has not changed. Lewis Avenue is to the right of the building. The structure contains 120 single apartments, a medical section, a cafeteria-style dining room, and social rooms.

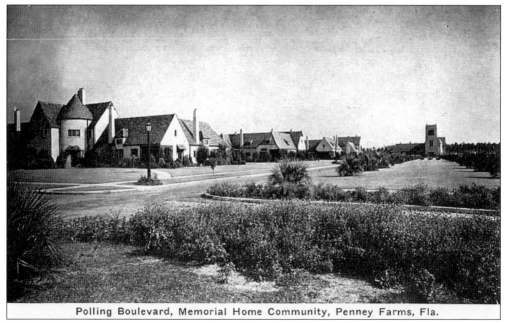

Polling Boulevard, Memorial Home Community, Penney Farms, Fla.

POLING BOULEVARD LOOKING NORTHEAST TOWARDS THE MEMORIAL CHURCH. The road was named after Dr. Daniel A. Poling, who, on Easter Sunday, April 5, 1942, baptized James Cash Penney in a private ceremony.

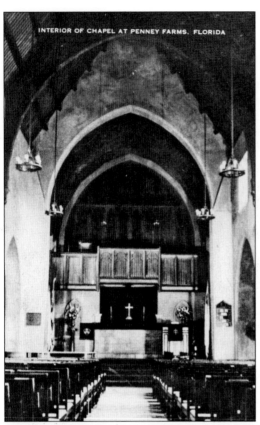

INTERIOR OF CHAPEL AT PENNEY FARMS, FLORIDA

INSIDE THE PENNEY MEMORIAL CHURCH. The church has soaring Gothic arches made from yellow pine and a magnificent pipe organ up front. Regular Sunday services are still held.

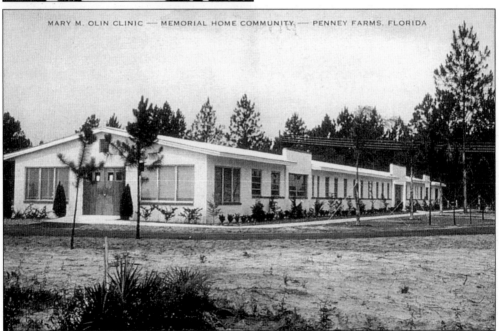

MARY M. OLIN CLINIC — MEMORIAL HOME COMMUNITY — PENNEY FARMS, FLORIDA

THE MARY M. OLIN CLINIC. A medical facility was established for the residents of the town, as the nearest hospital then was eight miles away in Green Cove Springs.

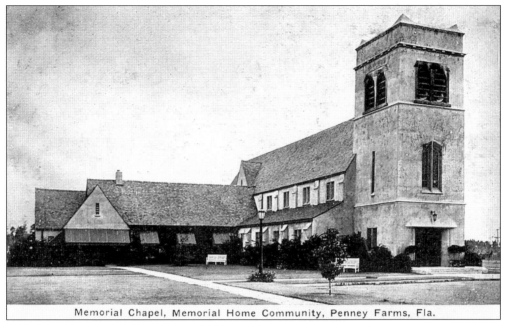

Memorial Chapel, Memorial Home Community, Penney Farms, Fla.

THE PENNEY MEMORIAL CHURCH. After a lengthy spiritual journey, J.C. Penney became a member of the church on May 14, 1950. Penney wanted the chapel to rise above the houses that surrounded it "as a reminder of the centrality of the Lord Jesus Christ and the constant presence of God the Father."

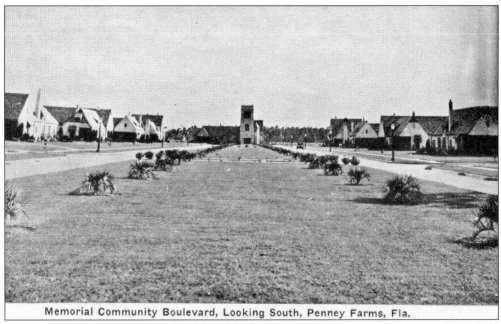

Memorial Community Boulevard, Looking South, Penney Farms, Fla.

MEMORIAL COMMUNITY BOULEVARD LOOKING SOUTH. From the main entrance located off Highway 16, a grassy avenue lined with palms invites guest and resident alike to enter the town of Penney Farms. (Courtesy of Matheson Museum.)

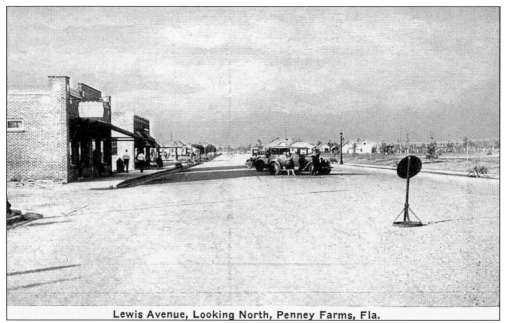

Lewis Avenue, Looking North, Penney Farms, Fla.

LEWIS AVENUE LOOKING NORTH. Lewis Avenue is the main business road in the town. Only the second of the two brick buildings stands today and it is used as the post office and a beauty salon. The other brick building on the left was burned down in a fire training exercise in the late 1990s.

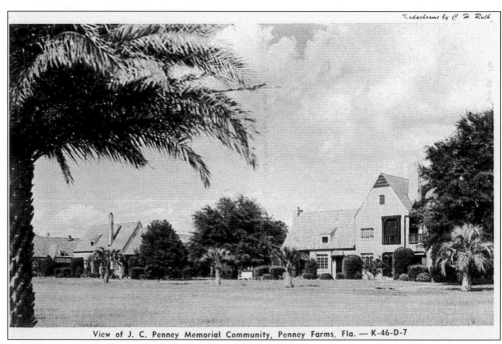

View of J. C. Penney Memorial Community, Penney Farms, Fla. — K-46-D-7

A VIEW OF J.C. PENNEY MEMORIAL COMMUNITY. Today, 75 years after its establishment, the town remains the same. One new resident wrote in November 1932 when they first arrived that "everyone in town is very kind and thoughtful."

Ten

CAMP BLANDING

Camp Blanding came about as a necessity for the National Guard of Florida. Prior to Camp Blanding, the Florida National Guard trained at Camp Foster in Jacksonville along the banks of the St. Johns River. In 1939, the navy was looking for a site to establish an air station. The state would relinquish its right to the property if compensated. On September 11, 1939, an agreement was signed and the State Armory Board received $400,000 to establish a new training site. In six separate transactions, 28,200 acres were purchased from Foremost Properties, Inc. On January 1, 1940, the adjutant general of Florida issued General Order 1, formally naming the new site Camp Albert H. Blanding. Major General Blanding had served many years in the Florida Guard, first enlisting in 1895 in the Gainesville Guards. On November 9, 1940, he retired after a distinguished career. By the end of World War II the total cost of Camp Blanding to the federal government was calculated at almost $43 million. The facilities were deemed expendable, as the cost to make Blanding a permanent post was too high. By 1947, the buildings were being auctioned off to the highest bidder. Today Camp Blanding is the training site for the Florida National Guard and it contains the largest museum in Clay County.

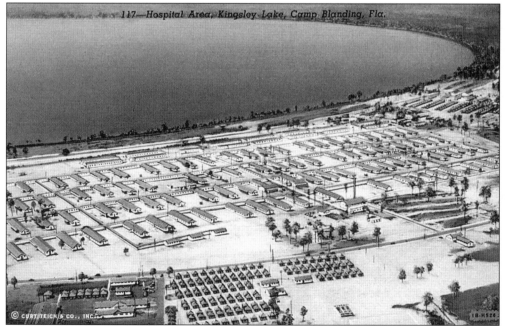

THE HOSPITAL AREA OF CAMP BLANDING. Camp Blanding contained the largest hospital complex in Northeast Florida during the war. Towards the end of World War II, it was designated as a regional hospital that was to serve all other posts in the area.

117

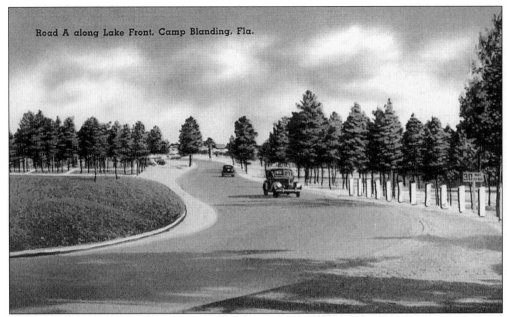

Road A along Lake Front, Camp Blanding, Fla.

ROAD A ALONG THE LAKEFRONT. Today this Road A runs parallel to Kingsley Lake. This road was one of the 55 miles of paved roads that ran throughout the camp. There was also an additional 350–500 miles of secondary roads and trails constructed.

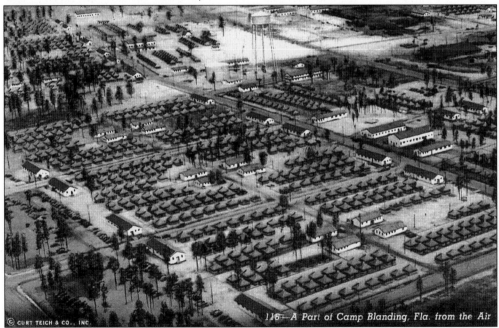

116—A Part of Camp Blanding, Fla. from the Air

CAMP BLANDING FROM THE AIR. Camp Blanding sprang out from the wilderness of Clay County. In a written statement, the camp's commander, Col. R.H. Kelley, stated that "in less than six months' time . . . a growing community with a population soon to rank fourth in the state" will exist. By early 1941, Colonel Kelley reported that 41 miles of sewer pipe had been laid, 5 water tanks erected, 33 miles of telephone wire strung, and over 1,150 structures built for various purposes.

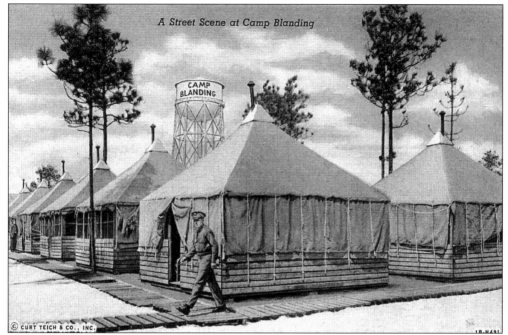

A Street Scene at Camp Blanding

A STREET SCENE. Instead of building barracks for the troops, small wood frames were constructed with a canvas top and sides that could roll up. Camp Blanding was called a "tent camp" and some 11,000 tents were erected. Both officers and enlisted men were housed in the tents. Each tent would house one to three officers or five to six enlisted men.

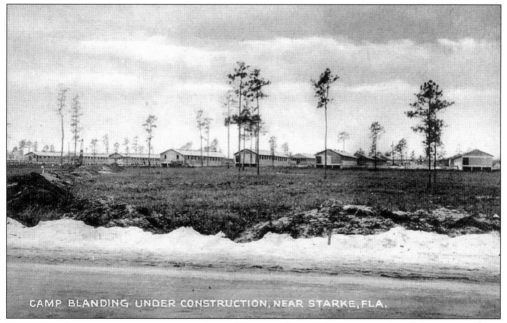

CAMP BLANDING UNDER CONSTRUCTION, NEAR STARKE, FLA.

CAMP BLANDING UNDER CONSTRUCTION. Construction of the camp entitled the nearby town of Starke to call itself "Boomtown USA." During the construction, the number of workers peaked at 21,000. At year's end in 1940, local merchants reported significant increases in business transactions from the year before.

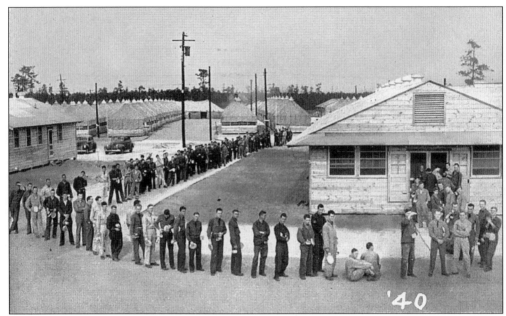

RECEPTION CENTER AND MESS LINE. At the reception center a new soldier was quickly introduced to army life. Here he was given a final thorough medical examination and issued uniforms and other equipment needed for training. In its first three weeks of operations, the reception center processed 2,224 men.

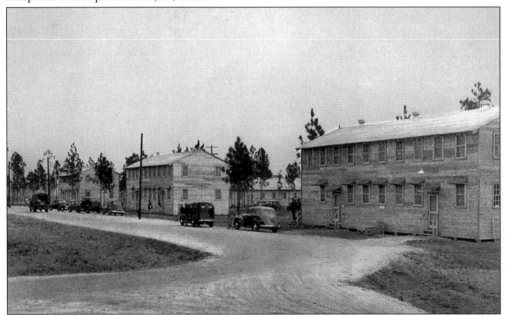

HEADQUARTERS, 31ST INFANTRY DIVISION. The first unit to arrive was the 31st Division, called the Dixie Division because it was comprised of National Guard troops from Alabama, Florida, Louisiana, and Mississippi. On the troops' arrival in December 1940, they found a half-complete camp waiting for them. Nonetheless, those personnel who had trade skills in construction helped to construct the camp. In February, 7,143 troops arrived to start their training.

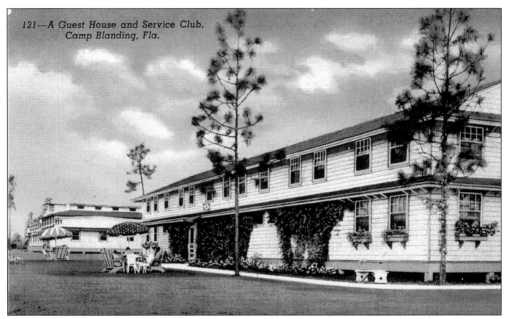

121—A Guest House and Service Club, Camp Blanding, Fla.

THE GUEST HOUSE AND SERVICE CLUB. In order to help meet the needs of visitors, Camp Blanding had three guesthouses and two annexes. By 1944 the guesthouses had provided services to 30,000 visitors. There were three service clubs for the enlisted men. Each club had a dance hall, cafeteria, and library. The club was open from 1000 hours to 2230 hours.

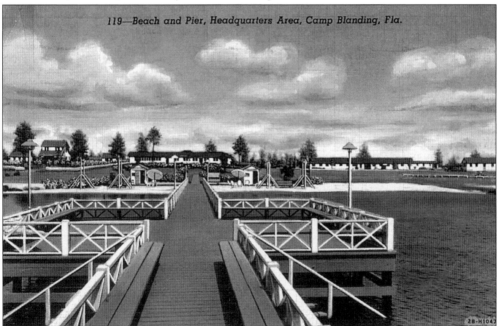

119—Beach and Pier, Headquarters Area, Camp Blanding, Fla.

THE BEACH AND PIER, HEADQUARTERS AREA. Camp Blanding borders the eastern side of Kingsley Lake, a beautiful sand-bottom, spring-fed lake. The lake provided cool relief from the beating summer heat. Swimming hours were determined by regimental commanders, but no swimming was allowed during training hours. Qualified lifeguards were provided at all times when swimming was allowed.

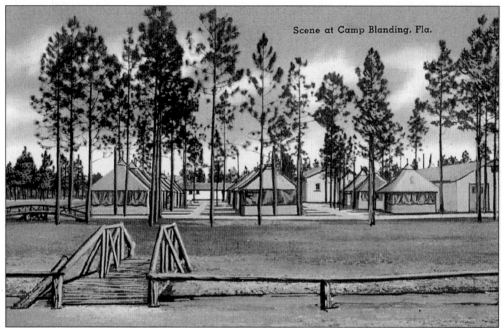

A SCENE AT CAMP BLANDING. The "tent cities" were carefully laid out in the open pine forests. Much of the vegetation was removed from the sites, leaving the sun to reflect off the white sand-hills, thus making this post one of the hottest in Florida. Plank sidewalks were constructed and provided streets between the rows of tents.

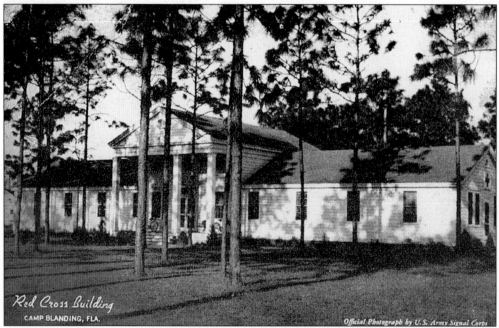

Red Cross Building
CAMP BLANDING, FLA.

Official Photograph by U.S. Army Signal Corps

THE RED CROSS BUILDING. In addition to providing services at the post hospital, the Red Cross also provided emergency loans to soldiers, assisted with personal or business problems, and helped to locate a soldier's family. The headquarters were located directly across from Theatre No. 5 at the junction of Vermont and Burlington Avenues.

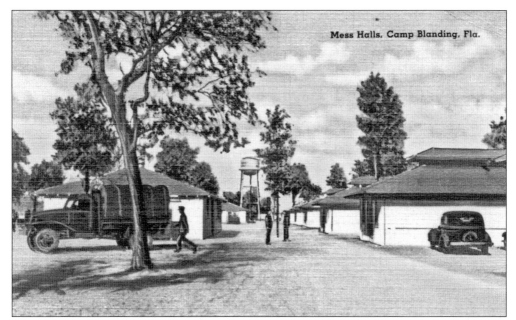

MESS HALLS. The cooks for the military had a very busy job, providing meals for the 40,000 soldiers who were going though infantry training. Extra help was provided by those unfortunate to be selected for KP duty. KP duty usually started at 0430 hours and ran until 2100 hours. It was a long day of cleaning pots and pans, emptying garbage cans, and other duties. (Courtesy of Clay County Archives.)

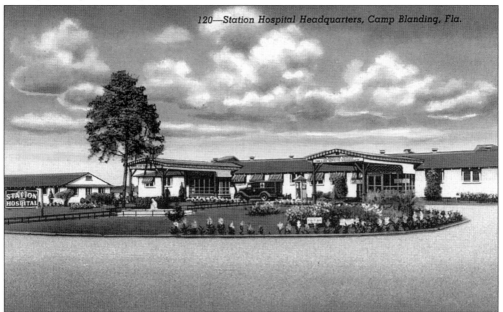

STATION HOSPITAL HEADQUARTERS. Col. L.R. Poust was the hospital's first commanding officer. He was responsible for creating the different departments within the hospital that were needed. At the end of its first year of operation, the hospital had treated 22,047 patients with a staff of 132 officers, 150 nurses, 331 enlisted men, and 537 civilian employees. On April 8, 1942, Colonel Poust turned the command over to Lt. Col. William T. Weissinger.

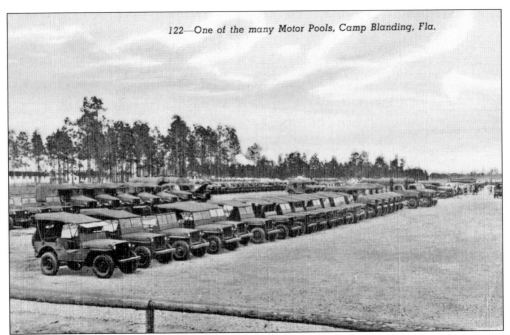

122—One of the many Motor Pools, Camp Blanding, Fla.

ONE OF THE MANY MOTOR POOLS. The military's need to provide transportation to soldiers in combat was vital to all units in the army. The motor pools for the nine infantry divisions that trained at Camp Blanding covered many acres. The vehicles included jeeps, "deuce-and-a-halfs," and two-ton trucks used to tow artillery and haul troops. Other motor pools included track vehicles, including tanks. (Courtesy of Clay County Archives.)

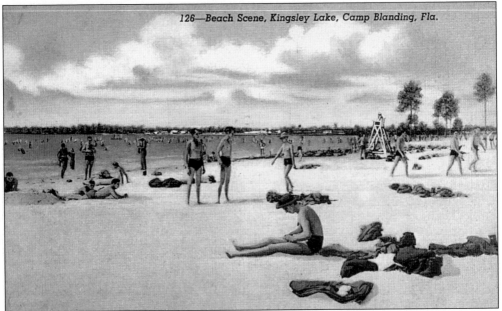

126—Beach Scene, Kingsley Lake, Camp Blanding, Fla.

A BEACH SCENE AT KINGSLEY LAKE. Zephaniah Kingsley, for whom the lake is named, owned several thousand acres in the area during the early 19th century. Within Camp Blanding there are several other sand-bottom lakes. At the end of the war, the lakes were stocked with fish from the Florida Game Commission and today they still provide some excellent fishing.

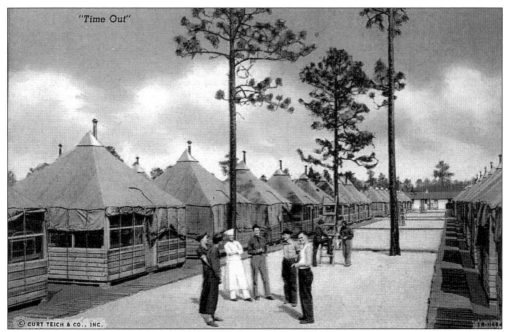

"Time Out"

© CURT TEICH & CO., INC.

TIME OUT. Any free time a soldier was permitted was valuable. When "off-post" passes were permitted, soldiers visited Starke, Gainesville, St. Augustine, Jacksonville, and any other place a bus or train would take them. A bus to Jacksonville cost $1.20 round-trip, and on a typical weekend pass the soldiers spent an average of $21,000 per weekend. USO shows were a big draw and Starke had three USO clubs in town.

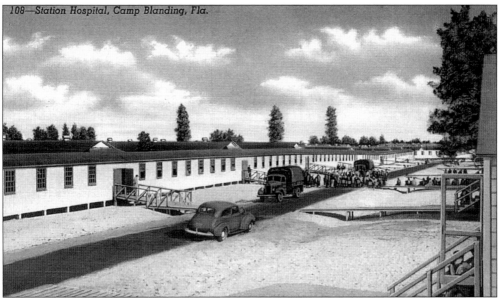

108—Station Hospital, Camp Blanding, Fla.

THE STATION HOSPITAL. When Camp Blanding was first built, the army required a 2,000-bed facility, but by 1943 a 2,800-bed capacity was needed. The camp hospital employed over 2,000 personnel and attended to an average of 62,600 medical cases per month. The Red Cross also helped to staff the hospital, and the library it established contained over 2,000 books. Col. Charles B. Callard was the hospital's commanding officer for the majority of the war.

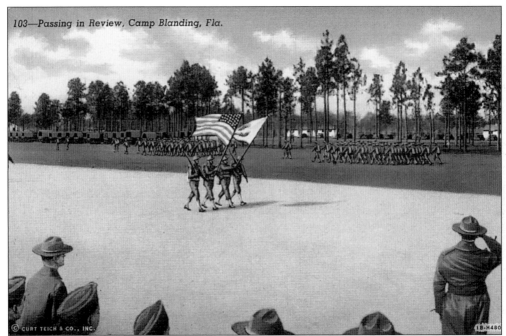

PASSING IN REVIEW. Camp Blanding was home to nine army infantry divisions, the 1st, 29th, 30th, 31st, 36th, 43rd, 63rd, 66th, and 79th; and one airborne infantry regiment, the 508th "Red Devils." These divisions comprised approximately 180,000 men and all fought in Europe except for the 31st and 43rd, which fought in the Pacific Theater.

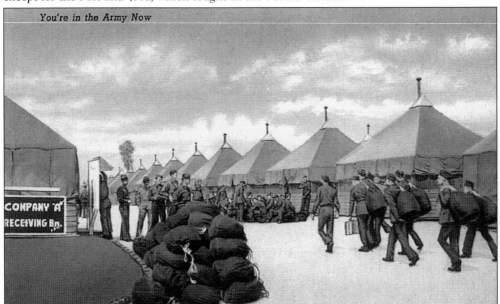

You're in the Army Now

YOU'RE IN THE ARMY NOW. Once the last of the army infantry division left Camp Blanding in the summer of 1943, the post quickly transformed into an Infantry Replacement Training Center (IRTC). The IRTC were established to provide 17 weeks of intense infantry training for new recruits. Once the training was complete the soldiers were be shipped to those divisions, which needed replacements.

126

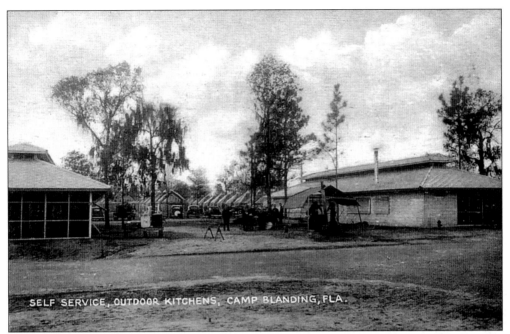

SELF SERVICE, OUTDOOR KITCHENS, CAMP BLANDING, FLA.

OUTDOOR KITCHENS. These portable kitchens helped to provide food for the troops who were out in the field training. Since food was a big expense, every effort was made to reduce cost at Camp Blanding. German POWs were used to harvest crops in the area, and by war's end Camp Blanding's Victory Garden, which covered 40 acres, was used to help supply the post with fresh vegetables.

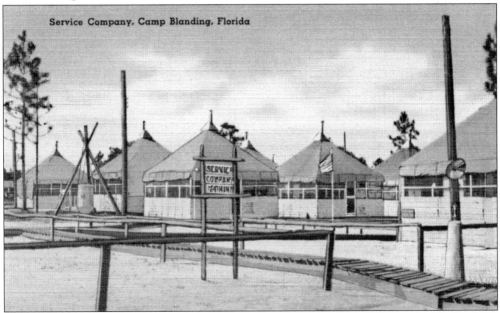

Service Company, Camp Blanding, Florida

SERVICE COMPANY. Each infantry regiment had one service company, and their job was to help supply the necessary equipment and transportation needed by the regiment. This postcard shows the service company area for the 124th Infantry Regiment, which was part of the 31st Infantry Division. (Courtesy of Clay County Archives.)

BIBLIOGRAPHY

American Missionary Association. *Announcement of the Orange Park Normal and Manual Training School, 1911–1912.* Orange Park, FL: American Missionary Association, 1912.

Barbour, George M. *Florida for Tourists, Invalids, and Settlers.* New York: D. Appleton and Company, 1881.

Blakey, Arch Fredric. *Parade of Memories: A History of Clay County, Florida.* Jacksonville, FL: Clay County Bicentennial Steering Committee, 1976.

Board of Clay County Commissioners. *Who's Who Politically Speaking in Clay County, Florida, 1858–1886.* Clay County, FL: Guild Press, 1988.

Brinton, Daniel G. *A Guide-Book of Florida and the South.* Philadelphia: George Maclean, 1869.

Clay County Court Records: Law and Chancery Files, #558. *John Frank Jewelry Co. v. Magnolia Hotel,* 1909.

Clay County Court Records: Law and Chancery Files, #932. *Applegate v. Peeler,* 1902.

Clay County Deed Book D and E.

Clay County Tax Book 1869, 1874, 1876, 1882.

Davidson, James Wood. *The Florida of To-Day.* New York: D. Appleton and Company, 1889.

The Florida Daily Times. 27 January 1883.

Florida Military Academy: information packet and application, 1924.

Gardiner, R.S. *A Guide to Florida, "The Land of Flowers."* New York: Cusing, Bardua, and Co., 1872.

Green Cove Springs, Florida: Where to Go, How to Reach There, What to Take. Green Cove Springs, FL, undated.

IRTC Handbook Camp Blanding Florida. Starke, FL: Special Service IRTC Camp Blanding, 1943.

Ledyard, Bill. *A Winter in Florida.* New York: Wood & Holbrook, 1869.

Minutes of the County Commissioners, Book 1.

Mueller, Edward A. *Steamboating on the St. Johns, 1830–1885.* Melbourne, FL: Kellersberger Fund of South Brevard Historical Society, 1980.

Notes on a Trip to Florida. March 1885 (Clay County Archives vertical files).

Robison, A.A. *Florida: A Pamphlet Descriptive of its History, Topography, Climate, and Soil.* Tallahassee: The Floridian Book and Job Office, 1882.

Smith, W. Stanford. *Camp Blanding, Florida: Star In Peace and War.* Fuquay-Varina, NC: Research Triangle Publishing, 1998.

The Spring. 13 August 1887.

Tibbetts, Orlando L. *The Spiritual Journey of J.C. Penney.* Danbury, CT: Rutledge Books, Inc, 1999.

The War of the Rebellion. Washington, D.C.: Government Printing Office, 1891.

The Weekly Floridian. 6 January 1880.

Webb, Wanton S. *Webb's Historical, Industrial and Biographical Florida.* New York: 1885.

White, J.W. *Jacksonville, Florida and Surrounding Towns.* Jacksonville: 1889.